PORTLAND'S
LOST
WATERFRONT

PORTLAND'S
LOST
WATERFRONT

TALL SHIPS, STEAM MILLS AND SAILORS' BOARDINGHOUSES

BARNEY BLALOCK

Charleston London

THE
History
PRESS

Published by The History Press
Charleston, SC 29403
www.historypress.net

Front cover, top: Wheat fleet at Mersey dock. Late 1890s. *Copyright Thomas Robinson.*
Front cover, bottom: The rickety wharves of downtown Portland. Early 1900s. *Postcard from author's collection.*
Back cover: Detail from a photograph of Portland's lower harbor, circa 1890. *Copyright Thomas Robinson.*

First published 2012

Manufactured in the United States

ISBN 978.1.60949.595.4

Library of Congress CIP data applied for.

To Nektaria.

CONTENTS

PREFACE

When I first started working on the grain docks of Portland, I found myself thrust into a bewildering world that stretched north along the river from the Steel Bridge in the center of town, to the grain elevators beyond the Saint Johns Bridge. This world revolved around the life and traditions of the Portland longshoremen, a group interesting enough to have once been the subject of an anthropology textbook. I worked alongside the longshoremen—inspecting export grain for the United States Department of Agriculture (USDA)—for over thirty-three years. During these years, my interest in the history of this place became something of an obsession. In these pages I hope to share some of the high points of my discoveries covering the period from the early beginnings of the city up to the First World War.

This is the story of a rough-sawn village, up 113 twisting miles of sandbar and snag-infested rivers, and how it grew to become one of America's major seaports. We now sometimes hear the story that Captain John Couch declared Portland the end of navigation, and for this reason, it became a seaport, but the facts of the matter are far less cut and dried. It was a bold, and many said "foolhardy," move to establish a seaport so far from the sea. For the first sixty years, there was no guarantee that the experiment would work, that all the dredging, jetty building and careful piloting would bring the maritime world to Portland's doorstep. It was a peculiar time in history when the West was an empty canvas, and the painters on that canvas were as slipshod and sundry a bunch as has ever congregated in one section of the globe.

Preface

The Portland waterfront was a particularly interesting place. Like the river itself, the waterfront was the source of the city's life. The money that trickled out from the banks into the hands of waiters, barbers, streetcar men, newsboys and the like largely came from grain deals worked out in London and Liverpool. The gas that burned in the lamps was made with coal from Newcastle. The gravel mixed with the cement of solid downtown buildings came from ballast dug from the quarries of Liverpool. The connection with Great Britain could be seen reflected in the names of some of the big grain docks themselves: Greenwich, Mersey, Victoria. Like Portlanders today, the town people cared little for the maritime business of the city, but when tall masts lined the wharves, they knew the "grain fleet" was in town. Then the saloons of the north end would hear the varied accents of the British "tar." When things got "breezy," and the whooping was particularly loud, it was most likely the Sons of Neptune interacting with the Riders of the Sage—a state of affairs particularly unique to Portland.

This waterfront—with its ferries and steamboats, stevedores and crimps—is all but lost from memory today. It is my ambition, in writing this book, to remedy that situation somewhat.

I would like to thank my dear wife, whose skills in all things related to English far surpass my own, and without whose help this book would resemble a dinner fed to canines. I would also like to thank Thomas Robinson for allowing me to explore his magnificent Historic Photo Archives (the closest I will ever get to being in a time machine).

My deep thanks to Molly Blalock-Koral for using her skills as a librarian to help me find some very obscure materials, to Mary Blalock for her enthusiasm and to John Blalock for his skills as a photographer. Finally, I would like to thank Darcy Mahan for her expertise and Aubrie Koenig for her initial encouragement and valuable help along the way.

For more information on the history of the Portland waterfront, the reader is encouraged to visit my website, www.portlandwaterfront.org.

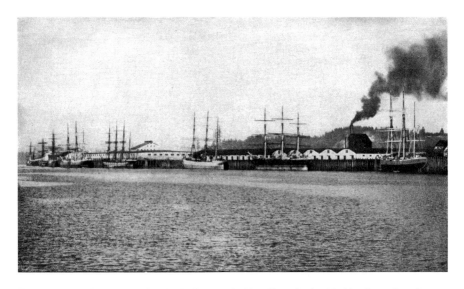

The Albina grain docks as they looked around 1900. *Singer Sewing Machine Co. trade card.*

CHAPTER 1

THE VILLAGE AT THE ENDS
OF THE EARTH

On this sunset bound of the union, the tides of immigration meet. The East and West here pass each other, and here the ends of the earth are linked. This country represents the last conquest of man over nature. There is no farther West for him to subdue.
—*Elwood Evans, History of the Pacific Northwest, 1889*

On the sunny morning of August 3, 1848, the schooner *Honolulu* arrived at the wharf in the new village of Portland, twelve miles north of the little town called Oregon City. A ship was a rare sight in this remote region. The few vessels that ventured up the Columbia usually went only as far as Fort Vancouver, the Hudson's Bay Company's regional headquarters. The previous year, the Oregon territorial government had established bar pilots in Astoria, but still few captains were willing to chance taking their vessels across a bar that U.S. Navy explorer Charles Wilkes called "one of the most fearful sights that can meet the eye of a sailor."[1] Once a ship was over the bar, within a few miles of Astoria, a large sandbar called the Hog's Back required even flat-bottomed steamboats to wait for the rising tide to pass. The other side of the Hog's Back, sandbars farther up the river and submerged snags from fallen giant fir trees threatened vessels at every bend.

In the Willamette valley, the energetic new farmers had come to find that there was no market equal to their efforts. Common goods necessary for a decent life were scarce or unavailable. The lumberyards were stocked

The *Glenesslin*, shipwrecked in 1913, shown in this dramatic picture of one of the victims of the "Graveyard of the Pacific." *Copyright Thomas Robinson.*

The Red House & Portland

Just received, per Toulon of New York, on con-
signment, the following goods, viz:
20 cased wooden clocks; 20 bsls dried apples,
 3 small mills; 1 doz. count sawblade,
Mill saws and saw saddles; mill cranks, plough
shares and pitch forkes,
1 winnowing machine; 100 casks cut nails,
50 boxes saddlers' tacks, 6 boxes carpenters' tacks;
12 doz. hand axes; 20 boxes shagged tobacco;
50,000 cigars; 50 kegs white lead;
100 kegs paints; 1-2 doz medicine chests;
50 bags Rio coffe; 25 bags pepper;
200 boxes soap;
50 cases boots and shoes, 6 dz slippers,
50 doz. sassaparilla; 10 bales shoostrings,
4 cases assorted prints;
1 bale damask Tartan shawls,
5 pieces striped jeans; 6 doz. mapinett jackets;
12 doz. linen duck pants; 6 doz. cotton
12 doz. red flannel shirts;
6 bals extra havy indigo blue cotton;
4 bals Mackanaw blankets;
150 casks and bbls. molasass;
450 bags sugar, &c., &c., for sale at reduced pri-
ces for cash, by

F.W PETTYGROVE

At the Red House, Oregon City, and at Portland,
12 miles below this city. Jan. 29, 1846-Swl

From an advertisement appearing in an Oregon City newspaper, the *Oregon Spectator*,
February through April of 1846, when Portland was just a few cabins. *Author's facsimile.*

full of lumber, the warehouses filled with grain and flour, but buyers were few, and prices offered were insultingly low. A letter printed in an Oregon City newspaper in 1846 stated that the community was "without the absolute necessaries for the support of the most economical farming community…many articles of clothing, and other articles absolutely necessary for our consumption, are not to be purchased in the country; our children are growing up in ignorance for want of school books to educate them, and there has not been a plow mould in the country for many months."[2]

Another letter told of how many of the inhabitants were, for the first time in their lives, facing the embarrassment of nakedness, and how there was not enough material available in the stores to make the "single leg of a pantaloon" for every male inhabitant.[3] It was a miserable state of affairs. Because of this great need for manufactured goods, any new vessel arriving in the area was greeted with curiosity and enthusiasm.

The *Honolulu's* master, Captain Newell, had received clearance in San Francisco for the Sandwich Islands but had instead changed course for the American settlements on the Willamette River. In a somewhat puzzled announcement of the arrival, the *Oregon Free Press* stated that the vessel had come "in ballast" (meaning, without cargo). An even odder aspect of this arrival was that the vessel "carried no newspapers." This was not only disappointing, it was also unheard of. To arrive at a remote settlement that was hungry for the news and gossip of the greater world without newspapers, and to arrive without carrying merchandise necessary for the survival and comfort of frontier families, bordered on outrage.

Adding to this frustration, this was during a time when the settlers felt themselves abandoned by the United States, something clearly outlined in a report in the *Oregon Free Press* of August 12, 1848, anticipating the arrival of the British naval vessel *Constance*, a fifty-gun frigate en route to the Sandwich Islands.

> *Her presence on our coast shows that the British interests in this part of the world are not neglected by the English Government;—we most heartily wish that we could say as much for the United States. It is now nearly two years since we have had an American vessel of war in our waters, notwithstanding the promise of Secretary Buchanan to the contrary; and it would really seem that American interests in Oregon were left to look out for themselves.*

Detail from a chart made by the Wilkes expedition in 1841 showing what would later be called Swan Island. The chart shows the river to be surprisingly shallow in many places. *U.S. Geodetic Survery, 1841.*

The sailors of the *Honolulu* were busily employed loading the holds with whatever picks and shovels, barrels of flour and other staples were available from the stores of the two local merchant sea captains, John Couch and Nathaniel Crosby, when the HMS *Constance* arrived in the Columbia River. The announcement in the *Oregon Free Press* of August 19, 1848, of this vessel's arrival is a jaw dropper:

> *The California "Fever"*
> *Since the arrival of the Frigate Constance, which brought the news of the condition of things in California, and "let the cat out of the bag" in reference to the object of the Schr. Honolulu in coming here so secretly, we have had a perfect "fever" of excitement about the gold harvest of California. The injunction of secrecy having been removed by the timely arrival of the Frigate, the officers of the Honolulu have divulged all that they know and have heard in regard to the gold mines and gold seeking in that country.*

The next week the *Oregon Free Press* reported under the heading "Oregon Exports, & Etc—"

> *The Honolulu left Portland last week with about 300 barrels of flour, and 200 of salmon, and some 50 passengers, who were allowed, we are informed, to take two barrels of flour each. We confess that we are unable to conceive where all this could be stowed on so small a craft.*[4]

THE "CAN'T GET AWAY CLUB"

The little village twelve miles below Oregon City would never be the same. Nor would the other settlements or the two rivers upon which they rested. The effect of the news was at first not a good one. The valley seemed as though it was going to depopulate as men of every sort and stripe packed up for California—farmers leaving their plows in the furrow, husbands abandoning families and merchants their shops. Those who stayed behind woefully called themselves the "Can't Get Away Club" and went back to their businesses with a heavy heart. But necessity being the mother of invention, there was now a pressing need for the goods of this valley. Sandbars would have to be dredged, charts drawn up, pilots trained, roads blasted through granite-walled mountainsides, telegraph wires run across empty miles and rails laid for locomotives—the long expected prosperity had arrived in one Eureka! of a cry—"Gold!"

An old-timer named William C. McKay said that when gold was discovered it "killed Oregon City...and gave Portland the supremacy." It is fairly easy, in hindsight, to see why this was true. Oregon City, cut off from receiving ships by the Clackamas river sandbar, was not in a position to "cash in," whereas all the fortunate planets were in alignment for its neighbor downstream.

By this time, the forest glade at Portland had already started to attract both businesses and residences. The merchants F.W. Pettygrove and Asa Lovejoy had purchased the land claim of a rambler named William Overton. Pettygrove had a store in Oregon City with merchandise he carried with him from the east coast. On his new claim in Portland, he constructed "a wharf and a large and commodious warehouse"[5] somewhere in the area of what would become the foot of Morrison street. He advertised both

of his establishments in the Oregon City newspapers as "The Red House and Portland, twelve miles below this city." Among some of the items listed in his inventory were fifty thousand cigars, two hundred dozen cotton handkerchiefs and twenty cases of wooden clocks. In the spirit of the well-rounded entrepreneur, he opened a slaughterhouse and a tannery, and in a stroke of genius, he instigated the construction of a plank road across what was often an impassably muddy gulch in the West Hills to the farmlands of North Plains.

It is obvious from these actions that Pettygrove had at one time believed that Portland would prosper. It is also possible that at some point he either lost faith in that belief or had a disagreement with his partners Benjamin Stark (who had purchased Lovejoy's claim on the city) and Captain Crosby, master of the ship *Toulon*. Five months before the arrival of the *Honolulu*, Pettygrove sold his 640 acres ("with the exception of certain lots"[6]), including the part of the claim belonging to Stark, who was in the eastern states at the time, to Daniel H. Lownsdale[7] and headed off for the Puget Sound. Starting with that transaction, the land would be divided and subdivided by a number of local merchants, sea captains and speculators. And since all of these early real estate deals were made before the laws of the United States extended over the Territory of Oregon, there would follow disputes and lawsuits, eventually even rising to the Supreme Court in Washington, D.C. These disputes, however, did not stop the deals from being made or the rough-sawn houses and shops from being erected. The early settlers were sure that once they came under the protection of U.S. laws, the claims made under the Oregon Provisional Government and the subsequent transactions would be upheld—and, for the most part, they were correct.

It is impossible to know how Portland specifically, and this area in general, would have grown had gold not been discovered—first in California, and then throughout parts of the Northwest. Once furs fell out of fashion, there was really nothing here that anyone in the eastern states needed badly enough to expend the effort it took to get it. The Sandwich Islands and some of the more northern Hudson's Bay Company (HBC) posts needed the agricultural products that Fort Vancouver provided, and for a short period (April 1846–February 1848), the war with Mexico gave a boost to the producers of the region. Had there not been gold, however, the area would have developed over many decades and not in the few short, legendary years when hordes, armies and multitudes of men, driven by the lust and aching desire for gold, turned the quiet mountains and river valleys of the West topsy-turvy.

AFTER THE GOLD STRIKE

Portland had a wharf, a warehouse and easy access to the wheat fields, the farms, the dairies and the sawmills of the Willamette valley. There was finally a market in nearby California for all the abundance of the valley, and the chances were that the farmers and merchants of the "Can't Get Away Club" would become far wealthier going about their normal business rather than "forsaking kith and kin and rushing to California to dig in the bowels of the harmless earth for gold."[8]

One of the members of this "club" described the situation in a clear and logical essay titled "Oregon—Gold," which was published in the *Spectator*.

> *All that Oregon wanted was a good market, and the facilities for carrying her produce to that market, and the protecting care of the home government; the home government, we trust, is about to extend her protecting care, the mines have already brought the desired market, the mines will bring the facilities for carrying provisions to the mines, and the mines will materially contribute to making Oregon known, and develop her great resources.*[9]

This was exactly the case. The next five years would see development at a scale beyond the wildest expectations of any settler. The (by then) several thousands of newcomers, the ones who didn't fly south, would find labors and rewards aplenty. Trees were felled; houses, businesses, warehouses and wharves were built. Every industry and trade was needed, every skill and talent. No man or woman could say that they had no one to employ them. The logging and clearing of land and the building of the new city at Portland was done in such haste that the hills around the city, even into the muddy streets of the town itself, were filled with the unyielding stumps of the now missing ancient giants. Detractors called it "Stumptown," and Stumptown it was—one of the many stump towns of the era where a metropolis went up faster than the stumps could be pulled. But this Stumptown was different—it was Stumptown with a future. The other stump towns would, over time, change their names to "ghost town."

Five years after the Oregon City newspapers reported the California gold strike, Portland was described by the *New York Times* as a prominent and upcoming seaport of the West.

Tall Ships, Steam Mills and Sailors' Boardinghouses

Portland possesses all the requisites for shipping, having sufficient depth of water for trading vessels of almost any size to anchor opposite the city. Three wharves have been erected, all of which are continually in requisition, having vessels either unlading merchandise for our traders, or taking in cargoes of lumber, hogs, chickens, and agricultural produce for San Francisco, or some foreign market.[10]

The article failed to mention that the "sufficient depth of water" was not available certain months of the year, but the idea of Portland as an inland seaport had taken hold on the imaginations of men—most importantly on men who were merchants with access to capital.

From that period on, the growth was continual. In 1853, the Stark Street Ferry joined the two Willamette banks. In 1855, a telegraph line joined the new city with Oregon City and points south. By 1856, there were water mains being laid. By 1857, a coal gas plant had been built and gas lines were connected across the city. A mere decade of progress had transformed a log cabin in the dell to a small but thriving city that could rival or exceed any of the other settlements on the northwest coast, such as Seattle to the north or Victoria on Vancouver Island to the northwest.

By the end of 1860, the city of Portland had an impressive waterfront. From south to north, there was Knott's Wharf on Water Street between Taylor and Salmon, Abernathy Wharf at the foot of Yamhill Street, Vaughn's Wharf at the foot of Morrison Street, Carter's Wharf at the foot of Alder Street, Pioneer Wharf (owned by Coffin and Abrams) at the foot of Washington Street, the huge Oregon Steamship and Navigation Company dock between Ash and Pine Streets and the almost as huge Portland Wharf (owned by Captain John Couch and Captain George H. Flanders) situated at the foot of C and D Streets. Many years later, these alphabetical streets of the north end would be christened with the names of early Portlanders, including some of the names of the owners of these very wharves.

The folks back east, either too settled or too old to travel, could sit by their cozy stove of an evening and read the travel writing that was so popular in the day. Portland, Oregon, being an exotic place at the world's end, sometimes found mention in these accounts. In 1865, after visiting the Pacific coast, one of the great travel writers, Samuel Bowles, wrote, "Portland has the air and the fact of a prosperous, energetic town, with a good deal of eastern leadership and tone to business and society and morals."[11]

A decade or so later, this statement would have been seen by some as either blind stupidity or sarcasm, but in 1865, it was an honest assessment.

THE OSN CO.

In the years before the transcontinental railroad, when wandering souls came to Portland from the east, they traveled down the "boiling, whirling, surging"[12] Columbia River on one of the vessels belonging to the Oregon Steam Navigation Company (OSN Co.). This rough new company held a tight monopoly on Columbia River travel for many decades and had no trouble "buying or whipping anything that disputed their sway."[13] One of the first cargoes carried by this company was a sultan's ransom of gold from the newly discovered gold fields in Idaho. In the early years of the 1860s, the gold transported down the Snake and Columbia Rivers by the OSN Co. surpassed in value by far all other cargoes, equaling by today's standards billions of dollars.

One of the founders of the OSN Co. was Captain John C. Ainsworth, a steamboat pilot from St. Louis who had been bitten by the Californian

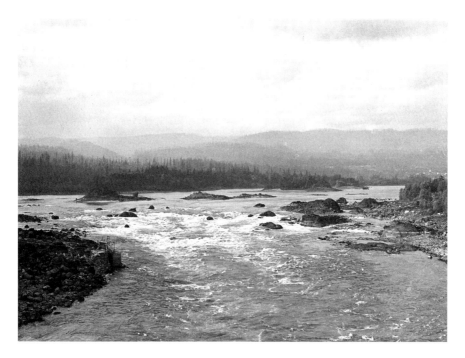

The Columbia River at the Cascades (now Cascade Locks). *Copyright Thomas Robinson.*

gold bug in 1849. After a discouraging stint at gold mining, he came up to the Willamette River to resume his old vocation as a steamboat pilot. He took the wheel of the first steamboat to be built in Oregon, the sidewheeler *Lot Whitcomb*, which left the "foot of the rapids" at Oregon City each Monday and Thursday for Astoria. In 1864, Captain Ainsworth oversaw the design and rebuilding of the OSN Co. Portland docks between Pine and Ash Streets. Prior to this time, all of the docks in Portland were a single level, making it difficult to load vessels when the river's height fluctuated greatly, as it did during the high waters caused by snow melt in the Cascade Mountains combined with the heavy rains of an Oregon spring. Ainsworth revolutionized the waterfront with a design of two-storied wharves that provided an upper deck to be used in the high water and a lower deck for the late summer and early autumn when the river was at its lowest. The new OSN Co. wharf was 250 feet long and was built at a cost of $50,000, many millions in today's money, making it an impressive gateway for the passengers arriving by water.

The lower "boiling, surging, whirling" Columbia River became impassable by river traffic at two points east of where it joined the Willamette: Celilo Falls, a drop of some twenty feet at low water, and Cascade Rapids below Hood River. By 1863, the OSN Co. had established portage railroads at each of these two bottlenecks: a 7-mile long railroad at the Cascade Rapids and the 13.8-mile portage at Celilo. There was no option but to use these portages. Brave and foolish souls could "shoot the rapids" at high water, but lives and cargoes were lost in the process.[14]

QUEENSTOWN FOR ORDERS

By the 1870s, the wealth of the Oregon and Idaho gold rush had started to recede. Portland merchants and bankers who had grown accustomed to dealing in gold turned their attention once again to the "golden harvest" of Willamette valley wheat, an old reliable standby and a perennial source of wealth since the days of John McLoughlin. Commission and shipping merchants such as John McCracken and Corbett & McCleary had taken up the task and had been moving wheat down the rivers and coastal waters by steamboats to San Francisco since the early years of the city.

On April 13, 1869,[15] when the waters of the Willamette were rising high with the spring snow melt, John McCracken inaugurated what was to be a new era in Portland history. His chartered bark *Helen Angier* left the Portland wheat docks on a voyage to Liverpool.[16] Other Portland merchants were soon to follow. Corbett & McCleary gambled on a shipment of wheat and canned salmon, for Liverpool as well, aboard the schooner *Adeline Elwood*.[17] When these efforts prospered, other merchants joined the ranks, and Portland became established as a port that traded regularly with Britain and its colonies, Europe and Asia. But the foremost destinations for wheat shipments in the coming decades were Queenstown[18] and Cork in Ireland with Liverpool following third. In fact, exports of wheat directly to any other destination than these were rare. Most vessels were directed to "Queenstown for orders." In the days before transatlantic telegraphy, vessels would arrive at Queenstown and await orders as to the destination of their cargo to be telegraphed from London.

From the very earliest days, it was apparent that the Willamette could not sustain deep-draught vessels year-round without the additional cost of dredging. Besides this, the time of year when the larger vessels would be most needed at the Portland wheat docks was in the months following the harvest when the river was at its lowest. A great hindrance to shipping around the time of the *Helen Angier's* voyage was a large sandbar near Swan Island. If Portland had not acquired men of influence in Washington, D.C., it is doubtful that the U.S. Corp of Engineers would have been sent to address such obstacles. The passage for grain shipments would have continued to be accomplished using shallow draft river steamers from the Willamette falls at Oregon City to grain warehouses of Astoria. It was the decision to keep the Columbia and Willamette Rivers dredged that created a metropolis at Portland more so than any other single decision in the history of the city. Had the river not been kept at a depth navigable to international shipping, the city would most certainly not have become the terminus of great railroads. The groundwork for this decision can be seen in the communication sent to the secretary of war by Major Henry M. Robert, army engineer in 1871:

> *There are two English firms in this city, Messrs. Corbett & McCleary, and Messrs. Hewitt, Flowerdon & Co., constantly engaged in shipping wheat directly to Liverpool, which, before the opening of the Swan Island Bar, found its exit by steamer to San Francisco, and there was reshipped for exportation. Since October last, the coin collections at this port alone*

amounted to $210,000, and more than twenty vessels with full cargoes have arrived in this river from distant foreign ports, taking out from hence full cargoes of domestic produce.[19]

It is interesting that one of the "Messrs." mentioned in his report as being partner in an "English firm," H.W. Corbett,[20] was at that very moment a seated U.S. senator from Oregon. Corbett—a grain merchant, banker and politician—would be a powerful influence in Washington into the early twentieth century. It can be seen from Major Robert's report, the Swan Island bar was not the only obstruction to be dealt with at the time. There were also large sandbars obstructing the Columbia. This report is valuable, not only as an artifact on the beginnings of dredging in these waters—a topic that has become quite heated in these environmentally aware times—but as a snapshot of river traffic at the time.

The following instances will evince the difficulties which confront the masters of large vessels coming to this port: The British bark Skidder, now in port from England, with railroad iron, was detained several days on the bar at the mouth of the Willamette, and only got over it by sending forward one-third of the cargo on lighters. The duty collected on this cargo exceeded $17,000. The British iron ship Dorenby, also in port now, with a similar cargo, grounded on the St. Helen's Bar, and was brought into port only by lightering. The duties paid on her cargo aggregated nearly $19,000. The American bark Garibaldi, just arrived with a full cargo from China, was delayed for some time on the St. Helen's Bar. Duties on her cargo exceeded $15,000. The British ship Bristolian, drawing 19 feet of water, is now in the mouth of the Columbia River, and steamboats are going down from here a distance of one hundred and ten miles to lighter her ere she can ascend the river to this point. All these ships are chartered to take return cargoes, one-half of which they will take at the wharves of this city, then dropping down below St. Helen's, a distance of thirty-five miles, will there receive the remainder from steamboats. In order to secure return cargoes of wheat, &c., vessels from distant ports must arrive here in the latter part of the summer, which is the season of extreme low water in these two rivers.[21]

The connection between Senator Corbett's influence in Washington and the dredging of the Columbia and Willamette can also be deduced in *Oregonian* articles as he repeatedly brought the issue before Congress. Finally, in 1872, he was successful:

Portland's first place of business was a log cabin "in the clearing." From *West Shore*, a literary magazine published in Portland, Oregon, from 1875 to 1891. *Copyright Thomas Robinson.*

A letter from Senator Corbett, which we publish today, gives information that he has succeeded in inducing the Senate Committee on commerce to agree to an appropriation of fifty thousand dollars to build and operate a dredger on the lower Wallamet and Columbia rivers. Work at Washington like this is what our State needs.[22]

Earlier, Senator Corbett had stepped in when Congress overlooked Portland as a final port of destination to which merchandise could be transported in bond when developing the tax codes. Otherwise, import merchants in Portland would have had to wait while their merchandise was detained in San Francisco for one month. He was also there in Congress when the land grants for railroads were being distributed to companies involved in the great race to cross and crisscross the country with rails. He was the right man, in the right place, to see that his little city was included in the world. Corbett, as an exporter of grain, an importer of sundry goods, a banker

and a charter member of the Northern Pacific Railway, had everything to gain in the process. In a speech made at Salem in 1872, Corbett spoke of his affection for his city: "I have been charged with being partial to Portland. I may have been selfish in my labors for her, but I have ever endeavored not to be unjust to any portion of the state. Portland is my home. I came to her twenty-one years ago—a poor boy. She has ever been kind to me. I have grown with her growth. I have strengthened with her strength."[23]

Corbett was not alone. Early on, Portland had attracted men of strong will and ability, men who either had or would soon obtain wealth, influence and political power—enough power to demand that the water channels be dredged deeper and wider for newer, larger vessels and power to influence the builders of railroads to make this their Pacific terminus. This was the ingredient that the other river towns on the Willamette and lower Columbia lacked, and it was this very human element—not the mythical "head of navigation"—that transformed the little stump town into a rich and powerful inland seaport with all the blessings and horrible afflictions that came along with that appellation.

Chapter 2

The Two Sisters

Two sisters walked by a miller's stream, O the wind and the rain
The one behind pushed the other one in, O the dreadful wind and rain.
 —*Scottish folk song*

DeWitt Clinton Ireland

In 1873, Astoria, the little town at the mouth of the Columbia, came out of its slumber to see that the world was its oyster—and this had nothing to do with the oyster beds in the nearby bays. Its most elite group of men—the Columbia bar pilots—had labored for years to rid the bar of its reputation as a widow maker, and they had succeeded. The past several years, there had been a minimal number of disasters, and even Captain Wilkes, who had formerly called it "one of the most fearful sights that can meet the eye of a sailor," would have to admit that, with the proper precautions and pilotage, it was a safe passage. The few log huts along the shore abandoned by the Hudson's Bay Company had grown over the years into a town with several sawmills, several canneries, some facilities for building schooners and now, a quality newspaper.

DeWitt Clinton Ireland was described by the editor of the Albany *Democrat* as a "red-headed, brandy-soaked specimen of humanity...white-

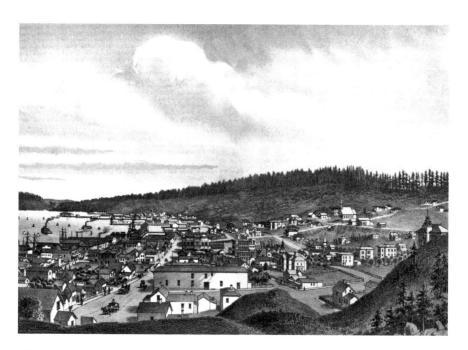

A bird's-eye view of Astoria in the late 1880s. *West Shore.*

livered libeler…liar, pimp, ninny, without honor and without principles—trickster, time server, unmitigated coward—blatant blackguard and poltroon,"[24] but since these are lines Mr. Ireland quoted, in a good-humored fashion, in his own autobiography, they are somehow relieved of their sting. D.C. (as he was called) moved to Astoria from Portland in 1873 to start a newspaper. He had been a well-liked reporter and had edited several newspapers previously, but he came to Astoria on a mission to awaken the inhabitants to take their rightful place in the world, to shake things up and to topple Portland from off its high horse. The first issue of the *Tri-Weekly Astorian* blasted off with both barrels in the beginning of what would be a relentless barrage against Portland for usurping Astoria's rightful place as "the Seaport of Oregon."

> *Here the commerce of the Pacific ocean may find a port with sufficient safe anchorage for perpetual security. Here, on the most direct route between Europe and the ports of Asia, China, and Japan, may the heaviest cargoes break bulk, for the speedier transportation across the continent of America by rail. Astoria is the most accessible port on the coast; is more directly on*

the through traveled route, and presents greater facilities for shipping and better inducements to capitalists than any other point in the northwest; and these facts are so little understood, even in Oregon, it seems imperative that a paper should be printed here to advance and advocate interests for the common good of all.[25]

In those by-gone days, vessels of all sorts had to wait for high tide in order to have deep enough water to come alongside the docks in Astoria. The streets were laid out to serve as docks by the water's edge, but the water would disappear at low tide, leaving mud flats.[26] The harbor was deep, however, and, in some places, seven miles wide. It served as an anchorage for the sailing ships and steamboats as they waited for pilots or the right conditions to ply their way cautiously up the Columbia and toward the mouth of the Willamette. If they were able, they would go on to the docks of Portland. If they were not able, due to low water or shifting sand bars, then they would stay at anchor in the deep harbor of Astoria while their cargo was "lightered," either to or from Portland, by smaller vessels. It was enough to turn a man's stomach, especially a man with a vision, like D.C. Ireland. He wanted Astoria to rise triumphant. The political power and the financial giants of the region lived in their English-style mansions in Portland, but Astoria had the mathematics of economy and reason on her side. They couldn't dig a deep ditch all the way to Portland just to please a few bankers and commission merchants, could they?

THE TACOMA SCARE

When the first *Tri-Weekly Astorian* rolled off the presses, the Great Northern Railroad tycoons, in cahoots with the Oregon Steam Navigation Company, had created a "scare" in Oregon by considering running a rail line from the Cascades (now Cascade Locks) to Tacoma, thereby turning Tacoma—not Portland or Astoria—into the great terminus of the Pacific Northwest. The *Astorian* editor labored under the conviction that if grain could be moved by rail to Astoria from the farmlands of the valley, it could lower the expenses of shipping and bring more business to the area. He saw Portland as an unnecessary bottleneck and a useless obstruction, big enough to ruin it for

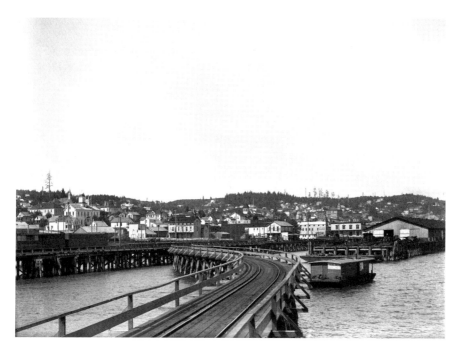

Tracks in Astoria for carrying crushed rock to build the jetty at the Columbia River's mouth around 1900. *Copyright Thomas Robinson.*

everyone if the Tacoma deal went through. An article on the subject ends with the dramatic plea:

> *Portland cannot get along without Astoria and the sooner she sees it in this light the better will it be for the commerce of Oregon,—which is already slipping quietly away into other channels, and unnatural ones at that. Let us unite and look out for home affairs—darn Tacoma, what's her business to us?* [27]

The paranoia about Tacoma was unfounded. The merchants and bankers of Portland were not about to allow such a thing.

D.C. carried on his campaign over the next seven years—three of them spent as mayor of the city. Like the tale of the little boy who cried out that the emperor was deficient in the wardrobe department, D.C. Ireland would point out the deficiencies of Portland in the seaport department. Finally, in 1880 he sold his newspaper to someone who would carry on the job of

waving the valiant Astorian banner, while he himself moved back to Portland to become a successful printer and a Republican party bigwig.

LIGHTERING FROM THE COLUMBIA'S MOUTH

To the ears of those living in latter times, the Astoria prophecies of missed opportunity and gathering doom tends to sound like the rantings of cranks. But most, if not all, of what was being said at the time was based on fact. Up until the period of deep dredging, which began around 1900, Portland was often found to be a port in name only.

The "Harbor and Shipping Committee" of the chamber of commerce gathered evidence of all these facts and presented them to the Willamette Valley Farmer's Convention in an effort to raise interest in the pressing need to lay a railroad from some yet to be chosen spot in the Willamette valley to the wharves of Astoria. The report pointed out the many favorable aspects of the harbor, docks and potential dock lands but went into greater detail enumerating the avarice, waste and folly of promoting Portland as a seaport. The report also pointed out the dishonesty involved in grain transactions, that the larger grain vessels of the day—three-thousand-ton schooners—were unable to load at Portland. The Customs House records show the schooners loading in Portland when, in actuality, "from one fourth to over one-half of the cargo was brought down to Astoria in steamboats and here put on board. And yet these records are more favorable to the city of Portland than the facts justify." This statement is supported by a list of the last season's grain vessels, the amounts loaded at Portland and the amounts lightered to Astoria.[28]

Another problem put forward by the committee was one of insurance. Underwriters would not cover deep water vessels when they "venture from their natural element" (or so said the committee); therefore, should a vessel strike a bar or hit snags within the river, even if there was no immediate damage, it would be enough to nullify the coverage, unless the vessel was put in dry-dock and the hull examined. And should this vessel be lost later on in its voyage, "not a dollar of insurance could be collected." Astorians could see it was obvious that the answer to all the difficulties encountered by shipping grain from Portland was simple—ship it from the safe harbor of Astoria instead. All that was needed was a railroad.

CROP OF 1872

1871	Ships	No. Bush. at Astoria	No. Bush. Portland
July 11 Oct. 11	Annie M. Small	7,971	42,452
" 14	Manilla	15,229	14,521
" 14	Navigator	7,359	20,622
" 14	Electra	7,734	22,177
Nov.7	Loch Dee	3,794	36,358
" 14	Siam	1,798	26,657
" 14	Forward, (bbls of flour)	10,117	3,200
" 21	Red Deer	20,052	26,501
'30	Grasmere	34,697	23,575
Dec11	Aouave	2,505	22,400
" 17	Naworth	8,495	17,170
" 18	Channel Light		21,755
" 21			
1873			
Jan. 18	Victoria Nyanza	9,625	44,800
Feb. 1	Whorington	14,880	31,654
'8	Felix Mendelsohn	11,573	33,003
"17	Sarah Scott	1,250	30,000
"20	Roswell Sprague	8,312	35,680
March 8	Illione	9,093	30,034
"10	Carribou	7,705	32,683
"14	Victoria Cross	3,828	24,342

From "Commercial Statistics," *Tri-Weekly Astorian*, July 1, 1873. A chart of grain lightered to Astoria yet shown on customs' records as having been shipped from Portland. *Author's facsimile.*

VILLARD WILL SEE THE LIGHT

In 1881, J.F. Halloran, the man who had taken up the torch lit by D.C. Ireland, was sure that the great man Henry Villard—the multimillionaire and head of the Northern Pacific Railway—would come to his senses and abandon Portland for the real seaport of Astoria. He wrote with confidence:

> *Among the probabilities of the near future is a railroad from the Willamette valley to Astoria. The many obstacles to successful navigation of the Columbia river from Astoria to Portland will be the cause which will effect the building of a railroad to the sea-board. Villard is largely interested in Portland it is true, to the extent of thousands of dollars, but one of these fine days he will unload his property interests there at a fabulous figure, and then, good bye to Portland's greatness.*[29]

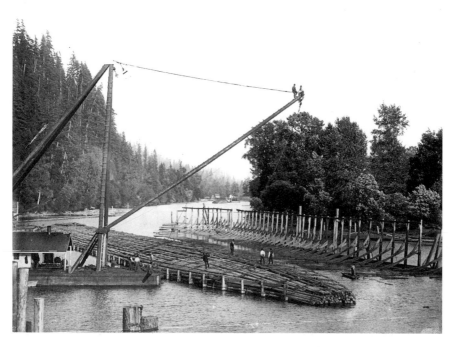

A log raft for transporting logs by oceangoing tug. *Copyright Thomas Robinson.*

Holloran's reassuring words to Astorians were all the more comforting since they were based on common sense. Now all that was needed was for the great man to open his eyes. They had no reason to doubt that he would. He was a wise capitalist who would soon see the light of dollars and sense.

> *The people of Portland wrongly imagine that Villard will make that place the chief city on the coast, but the great railroad magnate is not so silly as all that. He understands the value of a seaport town over an interior town, accessible only to light draught ships, and knows that the underwriters do not care to run a gauntlet of dangerous sand-bars in order to get produce which could be purchased at lower rates at the sea-board.[30]*

ASTORIA, THE PORT CITY OF OREGON

All through the decade of the 1880s and on into the 1890s, neither the great Villard nor any other capitalist could be persuaded to step forward as the savior of Oregon's seaport. The chamber of commerce created larger and larger subsidies and offered thousands of acres of prime real estate and large sums of money to lure a railroad to the city. Six attempts were initiated only to fall through. Then, in December 1893, a deal was made with a Montana businessman, and the Astoria and Columbia Railroad came into being.

To celebrate, the Astoria Chamber of Commerce took out a double-page advertisement in Portland's *Oregonian* newspaper with enormous headlines and articles detailing every aspect of Astoria's superiority, soon to be reached by rail.

> *Astoria By The Sea*
> *The Only Deep-Water Seaport In the State of Oregon*
> *AT THE MOUTH OF THE GREAT COLUMBIA RIVER*
> *There Is No Deep-Water Seaport In Southern Washington—Astoria's Harbor Is the Most Accessible on the Coast North of San Francisco*

Like many other "sister rivalries," the rivalry of Astoria with Portland was largely one-sided. Early on, the idea (whether or not it was grounded in fact) that Portland was at the head of navigation would be reinforced over and over again, as that city became the terminus for railroads and as the ditch

ASTORIA
Is the Deep Sea Port of Oregon.

STEAMSHIP LINES TO EVERY PORT ON THE PACIFIC COAST.

DEEPWATER SHIPS TO EVERY PORT IN THE WORLD.

AN INVITING FIELD TO CAPITALISTS AND MANUFACTURERS.

The inexhaustible resources of this vicinity are rapidly developing.

The opportunities for the agriculturist and immigrant are unequalled.

Government Lands abundant and Improved Farms are cheap in Astoria's Tributary Country now being opened by

NEW RAILROAD LINES APPROACHING COMPLETION.

THE MAIN LINE OF

THE ASTORIA AND SOUTH COAST RAILROAD

Diverges east from Clatsop Plains and traverses the Nehalem Valley to Trans-continental Connection at Hillsboro, Washington County. Surveying parties of three other great railroad companies are now in the field.

Astoria has an incomparable climate of perpetual Spring. **Labor** is always in demand. **Wages** are good. **Farm Products** find ready market.
Information furnished to strangers and immigrants seeking settlement.
Call upon or address

SECRETARY OF CHAMBER OF COMMERCE, ASTORIA, OREGON.

Astoria advertisement from an 1889 Union Pacific pamphlet, *Wealth and Resources of Oregon and Washington, the Pacific Northwest.*

to Portland was dug deeper and deeper to accommodate larger and larger vessels. The seventeen feet required when "Messrs. Corbett & McCleary"[31] requested appropriations for dredging by the U.S. Army grew to a depth of twenty-five feet in 1899, thirty feet in 1912, thirty-five feet after World War I[32] and so on.

When the long-awaited railroad was finally finished in 1898, it did not bring the dream of Astoria becoming a new San Francisco, but it did bring lots of Portlanders down to the seashore, and it carried away entire forests of lumber and countless cans of salmon. So in its own way, following its own course, Astoria prospered and grew to be a pleasant little town. Today Astoria is a town that is popular with tourists and filmmakers alike for its lovely old buildings and homes that never saw the bulldozers of prosperity.

There was a time, however, beginning in the late 1870s on into the early twentieth century, when the schooners and barks were moored at Astoria loading Portland's grain or Astoria's salmon, that the two sisters were perfectly matched in their rivalry. They both gained a reputation around the world, and especially in the chambers of shipping companies and on the docklands of Liverpool and London, for allowing a certain breed of tyrant to cheat sailors, blackmail sea captains and sometimes to ship unwilling landlubbers off to sea as sailors.

The Jolly Sons of Neptune Come to Portland

We are Liverpool born and bred,
We're strong in the arm but thick in the head.
—*Lines from a sea shanty*

The Coasting Trade

In the period before the railroads, the waterways were the highways of the Pacific Northwest, with a remarkable variety of steamboats. Some were built locally, with the machinery brought around the horn by sailing vessels. Most of the vessels were quite small by later standards and were often underpowered. This feature could create a dangerous situation if the captain allowed the boilers to become overheated. Boiler explosions were a common maritime disaster on the Columbia and Willamette Rivers in the early days, often causing loss of life to the passengers and crew.

At one time, the schoolchildren in Portland would recite a poem about the history of Oregon's steamboats which began:

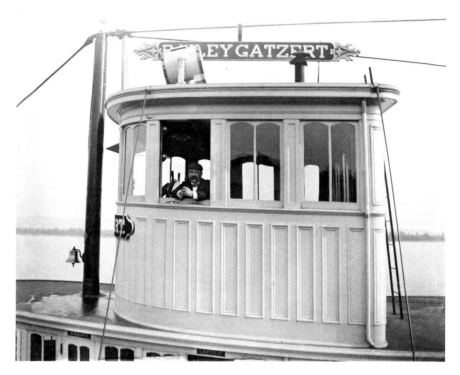

The captain of the sternwheeler *Bailey Gatzert* looks out on the world. *Copyright Thomas Robinson.*

The snug little Hoosier *was first to be ready*
To show that "where there's a will, there's a way."
Then the gallant Multnomah, *substantial and steady,*
Conveyed her rich cargoes to market each day.
The noisy Canemah *next graced the smooth waters,*
To show how business commercial was done,
And vowed that traffic no longer should loiter
While water could flow, or a steamer could run.[33]

Oceangoing steamers were common in Oregon as well, dating back to the Hudson's Bay Company's little steam boat, the SS *Beaver*, which ran the route from Sitka to Fort Vancouver. The *Beaver* was often called the "pioneer steamship of the Pacific coast, and first to sail the Atlantic," but in fact, the *Beaver* was built in London as a steamship, but to cross the

Atlantic and sail round the Horn, the paddle wheels were stowed in the holds and the vessel sailed as a bark.[34] The steamers used an enormous amount of fuel and could never venture far from a source of wood or coal. Many of the vessels were a combination of steam and sail, but the only economical way to transport cargoes, especially commodities such as grain, over the many thousands of miles involved in crossing oceans, was to use the power of the wind. This would hold true well into the twentieth century. In fact, sailing vessels would carry grain to Europe from Australia in what was called the "great grain race" up until the disruption caused by World War II in the 1940s.

The crews of the riverboats and coasting vessels were different from the sailors who sailed the high seas on the tall ships used in international maritime trade. One of the main differences was that, while the riverboat and coasting crews were mostly Americans, the vessels involved in international trade were almost entirely British, and the crewmembers were usually British subjects from some region of that far-flung empire. In that labor market, however, almost anyone would do, if they were strong enough to pull on a rope or scrub pots and swab decks. When the Portland commission merchants John McCracken and Corbett & McCleary started to trade directly with Britain, they opened a Pandora's box of sorts. Prior to this time, Portland was a relatively quiet place, compared to the lawless mining boomtowns, or compared to San Francisco, a city whose wild, vice-ridden streets were notorious around the world. San Francisco was also a place where the city government and police were at one time so completely corrupted that law enforcement was taken over by a vigilante system. Becoming a seaport would certainly put Portland on the map, but it was also a step that carried with it a great price.

THINGS GET "BREEZY"

As sailors came in larger numbers, so did the antics of the sailors—mostly young men, restrained for months on end to the confines of their vessels. In the winter of 1876, the *Oregonian* reported:

The wheat fleet at Mersey Dock in the 1890s. *Copyright Thomas Robinson.*

There are an unusual number of sailors now in port, and these jolly sons of Neptune make things quite "breezy" during the nights, much to the annoyance of the police. The officers occasionally teach these tars a salutary lesson, in showing them that "land lubbers" have rights which they are in duty bound to respect.[35]

These "sons of Neptune" were considered a distinct subclass of the human creature and were also known by the name of "Jack Tar," "common sailor," "lowly sailor," "forgotten soul," "rough sailor," "poor Jack," "sailor boy" or just plain "tar," to mention but a few applied to them by the newspapers and periodicals of the day. They were invariably drawn from the lower classes, and in the United States, they were not extended the same privileges by the Thirteenth Amendment to the Constitution as were the slaves who were freed thereby.[36] If, perchance, one of these "sons of Neptune" were to desert from his vessel to go ashore and seek other employment, he would become a hunted and despised criminal.

There were strong laws against desertion by sailors, and the full force of the police and U.S. Marshals were brought into play to make sure that

sailors signed onto vessels left port aboard those vessels. The odd thing about these laws is that from about the middle of the 1870s into the first decade of the twentieth century, a large percentage of the sailors arriving in Portland did indeed desert their ships, only to leave port shortly thereafter on another ship. The reason for this was a system of maritime employment that became common in seaports around the world involving the sailors' boardinghouses. This system was blatantly unjust and illegal, yet it held the maritime business of Portland and Astoria in an iron grip for more than three decades.

JACK TAR'S HARD LIFE

Typically, the ships traveling from Europe to Portland arrived either "in ballast" or with mixed cargo; they almost always left with grain and flour—sacked and stacked by hand, with each sack weighing about 240 pounds. They would take on crew and cargo at Liverpool, sailing for months to make the more than eighteen-thousand-mile journey around Tierra del Fuego and up the west coasts of the Americas. Here they would arrive with a crew of young men half driven to madness by the monotony of the voyage, sick to death of the stale, wormy sea hash and often worn to a humiliated frazzle by the lash and the stale breath of the first mate.

Even before the vessel was tied up along the wharf, she would be boarded by a "runner" from one of Portland's sailors' boardinghouses. Once aboard, these so-called "runners" would set themselves to the business of enticing members of the crew to leave the ship. The sailors were told that they were welcome to stay at the sailors' boardinghouse from which—after a period of relaxation—they would be shipped aboard a different vessel, one which invariably promised to pay higher wages than their current engagement. The lodging, board and "recreation" was offered at the sailors' boardinghouse expense and could be repaid with advance money from the new ship's captain when they left port. The runners would hand out cigars and sometimes liquor. Then they would guide their newfound "pals" along the waterfront streets to the boardinghouse.

One would think that the captain would intervene to stop this blatant desertion, but there were several factors at work here. First and foremost,

there was a financial incentive for the captain. According to British maritime law, the captain was entitled to keep the wages forfeited by a deserting sailor. There was also the lower cost to the ship to have no crew to house and feed during the weeks of unloading and loading cargo. Should a captain be resistant to this state of affairs, the crew would desert anyway, and the local sailors' boardinghouse men could cause a captain a great deal of trouble and sorrow by refusing to provide him with sailors once he had shown himself to be belligerent. There was also always the prevailing atmosphere of violence, with threats, spoken or unspoken. The number of captains who refused to go along with this system were very few and far between. Once a vessel was loaded and ready to sail, the captain would obtain a crew from one or more of the sailors' boardinghouses. The sailors' advance pay that was given to the boardinghouse master was called, at the time, "blood money."

Most, if not all of the sailors who stayed in these places were cheated "this way and sideways." The prices paid for room and lodging were much higher than other boardinghouses and hotels. The sailors' boardinghouse masters sometimes also provided sailors outfits of clothing and other gear needed for the voyage, at a margin of profit that was exorbitant. Since the bills were not settled up until the sailor was boarding his next vessel, it was settled between the sailors' boardinghouse master and the captain. Often times the "blood money" equaled the full amount of the sailor's advance pay. Many sailors came into port penniless and left port penniless, after spending a few short days feasting on boardinghouse stews and quaffing rotgut in the local saloons.

Had this nefarious business remained confined to those who had made a conscious choice to enter into the life of the sailor, then this cockeyed payment system would be just a minor footnote on maritime history. The need for sailors was, however, sometimes greater than the number of individuals who had chosen that vocation. The various methods of inducing members of the nonseafaring classes to become sailors was called "shanghaiing," and the shanghaier was often called a "crimp," a word of unknown origin but used throughout the seventeenth and eighteenth centuries for members of the man-stealing press gangs who forced unfortunate men into the Royal Navy.

To try and address this problem, the 1872 Congress passed the Shipping Commissioners Act wherein sailors were required to sign the ship's papers, or "articles," in the presence of a Shipping Commission official. And again, in 1884, the Dingly Act prohibited the practice of advance wages. There were

also Oregon state statutes against many of the practices of the shanghaiers. But these laws were only enforced occasionally and sporadically and were sometimes even dismantled in the legislature.

SAILORS' BOARDINGHOUSE OUTRAGES AND THE LAW

In 1874, when Portland was just starting to resemble a seaport and the word "crimp" was unknown to most Portlanders, this article appeared in the paper under the heading "SAILOR BOARDING-HOUSE OUTRAGES."

> *For some months past, British ship captains have made frequent complaint of certain keepers of sailor boarding-houses who make a business of decoying seamen from their vessels, thereby compelling the shipment of other seamen (usually from vessels which have suffered similarly) at double the customary wages. We are informed by some who have thus suffered, that it is the custom of these parties to board ships on their arrival in port and by the promise of higher wages, or other inducement, to entice the sailors into their low dens, where they are secreted until search for them has been abandoned. As soon as it can be done with safety, they are reshipped on some other vessel. Frequently the unsuspecting victims are plied with vile liquors until they are stupid, and in this condition they are induced to sign articles.*[37]

And then the article ended with this prophetic note:

> *[I]f the sailor boarding-house keepers, who are at the bottom of most of the difficulties between shipmasters and their crews, go unwhipped of justice the work of extirpating this evil will be only half done. Such practices tend to bring our port into bad repute. We hope District Attorney Mallory will push the prosecutions.*[38]

THE MIRACLE OF THE DANISH SHIP *JUPITER*

That was the attitude in 1874, a year in which only fifty-four foreign vessels took on cargo from Portland (and an undetermined percentage lightered to Astoria). As that number increased into the hundreds, Portlanders came to accept the fact that this was the way things operated. The crimps would work with impunity, their boardinghouses licensed by the city to operate. By the 1880s, even the "runners" would be licensed by the city and issued little brass pin-back badges as though they were officials of some sort.

The fact that the "blood money" system was the normal system in Portland for decades can be seen in a headline in the *Morning Oregonian* when a near miracle occurred on September 20, 1900—a Danish vessel, the *Jupiter*, left with the same crew it came with.

> *ONE SHIP ALL RIGHT*
> *Takes Away the Same Crew She Brought to Port. NO DESERTIONS, NO "BLOOD MONEY"*
> *The Danish ship Jupiter completed her cargo yesterday and will get away today with the same crew she brought into port. This has not happened here before for many a day "so long that we can't remember," as one of the exporters put it.*[39]

BLOOD MONEY

By the mid-1800s, this "blood money" system had developed in seaports around the world. There were many sailors who were used to the system and put up with it for as long as their bodies could stand the intense labor involved in operating a sailing vessel. They put up with the rotten food and hard labor, looking forward all the while to their next adventures in excess when they hit port. Any seaport town was accustomed to the fact that the dives and dens of the sailors, down near the wharves, were no place for a civilized human being to wander. In the larger seaport cities, filled with sailors, there were numerous sailors' boardinghouses. In 1874, New York City had no fewer than 169[40] on the books. When vessels were ready to sail,

it was normally easy to find a crew. In Portland, however, a newborn seaport at the ends of the earth (and her little sister, Astoria), if there weren't enough sailors, then "land lubbers" had to be shipped—one way or another. This is why "shanghaiing" (although practiced in other parts of the world) was such a West Coast institution, known in San Francisco and most every harbor north but common enough in Portland and Astoria to make the names of these two cities odious.

Sailors' boardinghouse masters were ruthless gangsters who often times had the authorities on their side. Captains had no choice but to take whatever crews they provided or to not sail at all. If they tried to provide their own crews, they would be blacklisted by the crimps. They would also face the very high risk of a violent attack. Rather than meet with a great deal of unpleasantness at the hand of scoundrels, ships' masters took what the crimps provided. On some occasions, they left the docks with so many "land lubbers" that the very safety of the ship was at risk; they could only hope to make it as far as San Francisco where there was the possibility of obtaining a crew of real sailors.

When a sailor deserted, preferring to forfeit his wages for an opportunity to ship elsewhere, that was one thing. But when the time for a vessel to sail was near and sailors were few, then the ugly underbelly of this already repulsive system came into play. It was then that a lone cowboy who wandered into town for a Saturday night, a visiting miner, logger, hobo or other wanderer was interrupted in the tale of their days to become a reluctant sailor upon the ocean blue. Sometimes a family man went missing, only to show up months or years later—if at all. There are even stories of prominent businessmen who were shanghaied. The methods of persuasion were diverse, but usually alcohol was involved. Contrary to local legend, and according to an old salt familiar with the Portland waterfront of the period, actual physical violence, such as knocking someone cold with a blow to the head, was almost never used. Usually it was drugged whiskey in one of the north end saloons or some sort of trickery played on young or inexperienced newcomers. Over the years, an untold number of men woke up with a terrible hangover onboard a vessel gliding down the Columbia River to the sea.

THE "SHANGHAI TUNNELS"

One of the earliest mentions of shanghai tunnels in Portland was in 1972 when a restaurant owner in the New Market Theater block of the old north end opened a bar called Darby O'Gill's in the basement, where there was a long dried-up drainage tunnel. The tunnel was sectioned into cubicles by the owner, who surmised it had once been used to shanghai sailors. Then, in 1975, some part-time college students devised a plan to start a museum in old town, with the shanghai tunnels as one of the features. They applied for a loan from the Small Business Administration to accomplish this pipe dream.[41] Prior to this project, I could find only one mention of "shanghai tunnels," a conjecture in a 1963 *Oregonian* article reporting on the demolition of a building in Chinatown.[42]

Anyone familiar with the practice in Portland will know one thing for certain: tunnels were unnecessary. In an interview with the old-timer, Spider Johnson, published in 1933, he told of a hackney driver named Tony Arnold who was in the business of driving nonambulatory men to their awaiting vessels. Tony Arnold was also in the business of making sure these "new sailors" were securely stowed aboard. This "shipping land lubbers" was not something that needed to be hidden in a tunnel. Once a drunken man had scrawled his name on the ship's papers or while he was lying in a stupor back at the boardinghouse and his name was signed by a runner, he was legally a sailor. The U.S. Marshals themselves would make certain that he sailed with the ship. Many is the time a group of new sailors started complaining that they were shanghaied. These complaints were almost always ignored, but if a captain feared that some of his crew would desert before crossing the Columbia bar, armed guards, often deputy U.S. Marshals would ride with the ship as far as Astoria. This happened so often that the *Astorian* began to jokingly refer to the U.S. Marshals as being in partnership with Jim Turk.[43]

It is entirely possible that some of the crimps of Portland had basement-level cages where they kept uncooperative individuals until such time as they were ready to "ship" them. No written evidence of this has ever surfaced and, had such a thing been discovered, it would have been decried in every newspaper. Those were the days when the cages built by society were much stronger than cages built of steel. Vagrancy was against the law and was usually punished by thirty days in jail. So from the perspective of the day, if some hapless soul ended up on a ship, he was no longer a vagrant. He

now had employment, a roof over his head and two meals a day. He may have signed the ship's papers in a drunken haze, but the papers were signed. Whining that he had been shanghaied would meet with no more sympathy than if today some young person were to claim that he was under the influence of drugs when he joined the army.

Shanghai Dock

For a short period of time, from 1923 until World War II, there was a dock in Portland called "Shanghai Dock." References to this dock have sometimes given rise to the erroneous notion that the word "Shanghai" had to do with the practice of shanghaiing. This dock has been mentioned as proof that shanghaiing went on as far upriver as Ross Island. The facts are far less romantic and occur in an era that is slightly beyond the period covered by this book.

The French bark *La Roche Foucauld* discharges ballast on the west shore, below the grain wharves. *Copyright Thomas Robinson.*

In 1923, the Shanghai Building Company established a dock to load lumber for China at the site where the Columbia Shipbuilding Company shipyards built vessels during World War I. From then on, the dock was known as Shanghai Dock, even after it was purchased by the Pacific Bridge Building Company several years later. It is almost amusing that this dock is mentioned (in hushed tones) by those who wish to embellish a tale of shanghaiing that needs no embellishing. I do admit that the name has a certain charm and would make a great title for a volume of pulp fiction or an adventure starring Tintin and Snowy.

THE SECRET PASSAGE ORDINANCE OF 1914

The tunnels that riddle Chinatown were mostly put there by Chinese. They were most often connected to gambling dens and were made as a means of escape should police or a rival gang show up. In 1914, the city council attempted to pass a "secret passage ordinance" making it illegal to have a secret passageway in any building in Portland.[44] This was seen by the Chinese as a law directed only at them, and a group of Chinese businessmen filed suit against Mayor Albee, Chief of Police Clark and Municipal Judge Stevenson. Among their arguments was the claim that it was against the Constitution because it did not protect against unreasonable searches and seizures, and it failed to define what constitutes a secret way or passage. The Chinese businessmen prevailed, and the ordinance was never put in place.

The tunnels became a public issue again in 1935 when a feature article on gambling in Chinatown was published in the *Sunday Oregonian*.[45] The article included drawings of some of the secret passages used in the gambling dens. These sorts of passageways and tunnels were a part of life in other cities with Chinatowns, especially Seattle and New York City. That these passageways became the substance of the "shanghai tunnels" myth is unfortunate because it arose, not as a folk tale, but from bad research. It is also an oversimplification of a story that is far more interesting. Compliancy in this trade involved men at every level of local government, which may be part of the reason the story was so well hidden from scrutiny for so many years.

People these days seem to find the tunnels' fiction easier to believe than the true story of deputy U.S. Marshals traveling with vessels to Astoria to make

certain that none of the shanghaied crew escaped this side of the Columbia bar. The Portland newspapers of the late nineteenth and early twentieth century are filled with matter-of-fact mentions of these kinds of events. Here is an example from the *Oregonian* about a crew "shipped" by a crimp famous in the latter period: "The British ship Star of Germany left down the river yesterday morning. The crew was shipped by Mr. 'Mysterious' Billy Smith, and the services of a deputy United States Marshal were enlisted to prevent them from getting away."[46]

DEMURAGE AND "LIBELING"

Cowardice and graft aside, another reason the system of sailors' boardinghouse masters held sway on the Portland waterfront was the ease with which they could detain a vessel by lawsuits brought against the master or other chief officers. A vessel could wait for weeks for a berth at a grain dock. It would then take weeks to be loaded with sacks of grain stacked by hand into every corner. Then, just as the anchor was going up and the tug was alongside, the U.S. Marshal would show up to arrest the captain on a charge trumped up by one of the local crimps. Oftentimes the vessels made it as far as Astoria before the U.S. Marshal arrived. Then the wheels of justice would roll slowly on until either the charges were finally dropped as being frivolous or a fine was paid. By that time the demurrage charges would have skyrocketed to such a degree that it would have been far better if the captain had agreed to everything the crimps demanded from the very first. This was a lesson quickly learned by anyone in the business.

This system worked so well for the crimps that shyster lawyers would hang around the sailor haunts looking for a good client, then as the ship was loaded and waiting for a favorable wind and tide, the notice would come that the ship was being "libeled" (the term in admiralty courts for lawsuits against a ship, ship's officer or owner). The libeling would be for such things as an onboard injury or back wages. When remarking on one of these very common libeling cases, in this case, a longshoreman falling through an open hatch (witnesses said he was drunk at the time), the *Oregonian* writer said: "Whether there is any justice to his claim or not, it will cause the ship captain some trouble and expense. There is a large

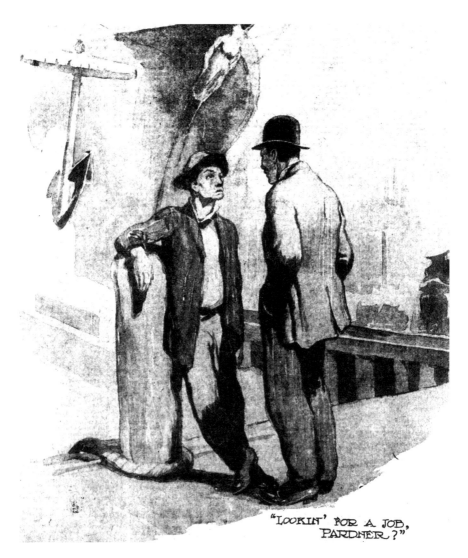

"Looking for a job, pardner?" A sailors' boardinghouse runner drums up business. *San Francisco Call (April 23, 1911).*

class in this community whose principle object in life is to make trouble and expense for others."[47]

A Seaport Does Not Come Cheaply

Portland had a bad reputation for other reasons as well—reasons that affected the bank accounts of British shipowners to a much greater degree. This letter to the *Liverpool Mercury* in 1881, wherein British ships' captains and masters vent their spleens, was reprinted in the *Oregonian* where it was denounced as inaccurate, but the arguments seem valid to the impartial eye:

> *To the Editor of the Liverpool Mercury,*
> *For the future guidance of shipowners and masters coming to this port we request you will be kind enough to insert this letter in your paper.*
> *Being interested in the shipping world, it behooves us to state that the exorbitant prices charged at this port surpasses any that have ever come before our notice. The freights, however, we will allow at the present time are very good. But to counteract this the danger connected with the bar, the pilotage and steam expenses on the river, are such that they literally swallow all the profits.*
> *The nature of this port is such that vessels have been known to stand off and on the port for a period of four and five weeks before an entrance could be afforded.*
> *There are many charges, we regret to state, which are well known to the inhabitants of this town to be an imposition. One we will mention is a charge for wharfage while a vessel is loading at Astoria, the wharves belonging to the same company in this city who also do all the lightering with their own steamers. The jealousy that exists between Portland and Astoria is such that only small portions of cargo are sent down, and that at long intervals, to any vessel loading at Astoria.*
> *Another very serious matter is that vessels consigned to Portland with only a very ordinary draught cannot be completely loaded there, and even then are frequently stuck on the river banks, the steamer charges still continuing at the rate of eight dollars per hour for the detention. We have known a case in which under these unjust rules a master had to pay $1740 for extra*

lighterage and detention. We may further say to strangers, opposition here in river towage seems to be very strong; but with a little personal observation it is not difficult to see how the two parties engaged in it join hand in hand. With regard to approaching Astoria bar there has been a great neglect on the part of the authorities in not making known to the shipping world the new lights that have been erected. We also think that the lifeboat authorities would do well to try and afford to keep more than one man. We have lately seen a case in which a whole ship's crew nearly perished, soldiers being the only volunteers of the lifeboat.

Vessels are frequently detained here for a length of time, owing to that unwarrantable practice of kidnapping the seamen immediately on the vessel's arrival.

WM. Jones, ship Derbyshire,
Jas. P Westland, ship Strathblane,
Capt. Crompton, bark Talt Sing,
Capt. Alexander, bark Mary Low,
Capt. Livingston, bark Lanarkshire,
John Morgans, ship Charles Worsley[48]

In 1907, when the era of shanghaiing was at its end, a retrospective in the *Oregonian* explained that during those eventful years few Portlanders had time to consider what was happening on the waterfront. "Then, as now, only a very small proportion of the people of Portland showed the slightest interest in the shipping business of port, but in those days we had not yet encountered the competition of rival ports sufficiently to create a general demand for reform."[49]

The businessmen connected to the port would work tirelessly to put to rest this bad reputation. By 1891, the port could claim to be a cheaper place to load than those of the Puget Sound, as well as San Francisco. There were inconveniences that were harder to manage than fee schedules, such as the arrival of the grain fleet in such a way that many vessels were kept standing in the harbor for weeks and the ever-recurring problem of the shallow months of autumn when lightering was almost always necessary.

THE SAILORS' BOARDING HOUSE ACT OF 1889[50]

In 1889, the Oregon legislature enacted a law that, among other things, made it illegal for a sailors' boardinghouse to charge more than a ten-dollar bonus for shipping a man. Depending on the time and circumstance, fees had ranged from thirty-five dollars to one hundred dollars, with a middle amount being more the norm. For a brief period, the authorities at Portland tried to enforce the law, but not so in Astoria. The city attorney, Noland, declared it "unconstitutional and void." Some crimps, including Jim Turk, moved their base of operations there to take advantage of the situation while it lasted.

In 1900, the Shipowners' Association in Liverpool made an agreement that the power to hire sailors in Portland should no longer rest with the captains but with agents at the port[51] from names taken at the office of the British vice consul, Laidlaw. Although this decision was often thwarted, it represented a new attitude toward crimping. The practice was already on the decline, but these sorts of decisions, along with actual enforcement of existing laws, would see the practice go extinct over the next several years.

CHAPTER 4

THE SAILORS'
BOARDINGHOUSE MASTERS

One of the sailors ran away
Got half drunk and he could not stay
Chased him down the Portland road
Hard to get away with the board he owed
—*The Sailors' Boarding House, traditional folk song*

Surprisingly little has been written about the sailors' boardinghouse masters of Portland, except for a few bizarre stories that have become a sort of "folklore" that is far less interesting than the actual events. This chapter will bring forward some of the more prominent members of this trade, although this is by no means a complete list.

JIM TURK AND HIS "BROOD"

In 1874, when the *Oregonian* told of British ship captains complaining against "certain sailors' boarding house keepers," the name that went unmentioned was that of James Turk. Turk was the first man to work the sailors' boardinghouse game in Portland. Turk was born in England in 1832. It is unknown when he came to this country, but according to records, he was a veteran of the Mexican War.

James was married to a fiery Irishwoman named Kate who was large in stature and said to be beautiful. He had two sons, Charles and Frank. Charles was most likely from an earlier marriage. In 1866, he set up a boardinghouse at 115 Jackson Street, in San Francisco, for which he obtained a license to sell liquor.[52] In 1871, shortly after Kate had given birth to Frank,[53] they moved to Portland and set up a sailors' boardinghouse, which is an odd thing, because in 1871, Portland was not much of a seaport. Only ten foreign vessels stopped at Portland that year, and coastwise sailors were not often to be found in such places.[54]

Jim was a big, smooth-shaven man who loved liquor and brawling. He was said to be a bully who would mercilessly rain down blows on someone, but only if that person was smaller or weaker. He was arrested

ENTRANCES AT PORTLAND FROM FOREIGN COUNTRIES.

Year.	American Vessels.		Foreign Vessels.		Totals.	
	No. of Vessels.	No. of Tons.	No. of Vessels.	No. of Tons.	No. of Vessels.	No. of Tons.
1870	34	19,581	13	7,468	47	27,049
1871	48	21,351	10	5,334	58	26,685
1872	26	11,946	14	9,140	40	21,086
1873	21	10,302	33	19,143	54	29,445
1874	20	11,766	56	34,063	76	45,829
1875	14	7,724	19	12,090	33	19,814
1876	18	9,102	63	47,780	81	56,882

CLEARANCES.

Year.	American Vessels.		Foreign Vessels.		Totals.	
1870	50	22,581	8	4,241	58	26,822
1871	56	29,261	22	12,795	78	42,056
1872	38	19,946	15	9,372	53	29,318
1873	34	19,444	36	23,476	70	42,920
1874	28	17,076	71	42,439	99	59,515
1875	58	22,988	31	27,691	89	50,679
1876	30	15,444	75	61,173	105	76,617

From the booklet *Oregon: Facts Regarding Its Climate, Soil, Mineral and Agricultural Resources, Means of Communication, Commerce and Industry, Laws, Etc.* (Boston: Oregon State Board of Immigration, 1877).

time and time again for brawling, assault and assault with a deadly weapon, wherein he was fined—sometimes large fines—in lieu of prison time. He always seemed to have plenty of ready cash. Kate was a chronic alcoholic who was also inclined toward brawling. Neither of them was ever able to stay out of the courts or out of the papers. Often, when mentioning the latest altercation, the editor would merely insert the heading: "Turk Again."

The Turk couple often waged furious battles with each other. After one such battle, in 1874, when it looked like Portland was rid of them, the *Oregonian* printed a blow-by-blow account of the events, calling them a "detestable pair." The article called Turk a "swaggering bully" and said of Kate that she was "a female of Amazonian proportions, with a temper alongside which Jezebel was an angel." Portland was not rid of the lovebirds—it was only a matter of months before they reconciled and were back in Portland setting up shop. They obtained a large house on the corner of First and B Streets, near the wharves, and christened it the "Sailor's Home." From this location, reports of drunken binges, lover's quarrels, brawls and shanghaiing would give reporters plenty to write about for years to come.

One day in October 1877, during the seemingly endless drizzle, a gentleman named T.J. Zingsen arrived on the packet from San Francisco with incredible news for Jim Turk. A relative in England had passed away, leaving him in excess of £25,000, which would make him more than a millionaire by current accounting. It was around this time that his mother came from Liverpool to live in the tumultuous house. Whether she came along with the inheritance money is unknown.

With his newfound wealth, Turk purchased a garish saloon with the even more garish name The Grand Central Varieties Saloon. The saloon had seventeen rooms. That fact, combined with the fact that this was Portland, most certainly means that its primary source of income was as a house of prostitution. Turk even dabbled in the restaurant business in Astoria, purchasing an establishment called the Delmonico. To the ears of a modern-day reader, the phrase "Delmonico Restaurant in Astoria" has an elegant ring to it, bringing to mind images of waiters in black tuxedos, starched linen table clothes and the faint aroma of garlic mixed with braising meat. However, this was Astoria, Oregon, where the town was built on stilts over the tide flats, and instead of sewers, there were holes in the floor for the ocean tides to act as a gigantic flush toilet. I rather suspect it was not a classy joint.

JAMES TURK

No. 42 First Street, Portland

"Shipping Clothier and Outfitter,

DEALER IN

Oil Clothing and Marine Furnishings of Every Description

Sailors' Complete Outfits a Specialty,,

From an advertisement placed by Jim Turk, which appeared for several weeks in the *Morning Oregonian* during October and November 1881. *Author's facsimile.*

The newly wealthy Jim and Kate did not leave the business of sailors, though they moved their Portland business to a better location between Front and First on C Street. For some reason, known only to Turk himself, he had the audacity to name the new establishment The Portland Hotel even though the billionaire railroad magnate Henry Villard was building a gigantic stone edifice, with 326 rooms, by that same name uptown between Morrison and Yamhill at Sixth Street.

It is known that Jim Turk, like most of the other crimps, operated from both Portland and Astoria. In Portland, from 1876 until 1887, Turk maintained a sailors' boardinghouse at 9 C (now N.W. Couch) Street, between Front and First Streets. This was in the area called "Whitechapel," one block from the Allen & Lewis Wharf. In 1888, this address became a flophouse called the Roma Hotel. That year, Turk moved his sailors' boardinghouse to 109 North First—a block that was nearly empty, except for a streetcar stables—on land recently reclaimed from an area containing a swamp-water lake. The next year, 1889 (the year the Oregon legislature passed anti-crimping laws), is the only year that Turk did not maintain a listing in the Portland city directory, operating only in Astoria.

Turk was often accused of shanghaiing, although the legal establishment rarely interfered with his business dealings. It was more difficult for them to avert their eyes from his drunken assaults. One of the more shocking of these assaults happened in the offices of James Laidlaw, British vice consul. Turk and his son Charles beat a man named Neville nearly to death, and when a bystander begged them to stop, they beat the bystander as well. Turk was fined a mere fifty dollars for this action.

Turk or his runners (often either one of his boys or someone like the Astorian hoodlum Paddy Lynch) would meet the British sailing ships as they tied up at the wharf, to entice the lads to desert. Though against the law, it was very rare that anyone was prosecuted for this activity and then the charges were usually brought by a competing crimp. Captain W.H. Brodie, of the three-masted British ship *Orpheus*, sailed around the Horn forty or forty-five times. He once told of a time in Portland when Jim Turk stole his crew, then sold them back to him at a high rate—and then stole them again before he had a chance to set sail.

In 1889, things started to go downhill for Turk. It was a year in which he saw a lot of the inside of the courthouse. Once he was arrested for assaulting and threatening to kill Bunco Kelley. The Portland crimps Turk, Kelley and Sullivan carried on a relationship nearly as volatile as the marriage of Jim and Kate—cooperating for long periods and then bursting into violent conflict. Kelley might charge Turk with attempted murder one day and post his bail the next. During Turk's trial for attempting to murder Kelley, Kelley accused Turk of having gotten away with murder in the past, to which Turk offered no defense, except a tired, "Very good."

In September of that year, Turk was charged with harboring sailors from the British ship *Lord Canning*. The charges were brought by the ship's captain and Balfour & Guthrie Co., urged on by British consul Laidlaw, who hoped that they could finally start to put an end to this practice. Turk did not show up for the first court appearance. Instead, a doctor from Astoria declared that his patient was undergoing a severe case of alcoholic delirium tremors and would be unable to appear. When the trial finally took place and the prosecution failed to prove its case, new charges were brought against him. He was charged with boarding the vessel without the captain's approval, an activity that was against state and federal law. For this offense, he was fined $100.

A few months later, during the dreary January of 1890, Turk's wife, Kate, died and was put to rest in the Lone Fir Cemetery in a grave beside where

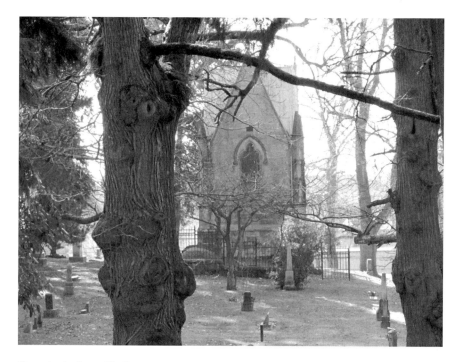

Crypt in the Lone Fir Cemetery near where Jim Turk is buried in a plot between his first wife and his mother. *Photo by Barney Blalock.*

Turk's mother lay. Kate was forty-seven years, nine months and seven days of age, according to the sentimental inscription on her tombstone. Alcohol had done its fatal best.

Four months later, Turk married a woman named Elizabeth M. Gardner in a civil ceremony. It seems he was growing tired of the crimping trade. He attempted to run a saloon in Portland on the northwest corner of Eighth and Front Streets. For the next several years, Turk and his new wife moved about between Portland, Astoria and finally Tacoma, where it is assumed his son Charles now lived.

James Turk died in Tacoma on January 4, 1895. He was sixty-three years of age. His funeral was held in Portland, and he was laid to rest beside his first wife in the Lone Fir Cemetery. According to the *Oregonian's* death notice, his reputation was known in "every port in the world." His death marked the beginning of the end of the era of shanghaiing—not only in Portland but also across the entire world. Turk died with an estate estimated to be worth $30,000, which in 2012 dollars is $1,110,000. The

estate included a farm in Troutdale and property in the city of Grants Pass. Considering that there were taxes and other debts to be paid from the estate, Turk could not be said to have died a very wealthy man. He, and the entire world, would have been better off had he directed his energies toward some higher endeavor.

JOSEPH "BUNCO" (ALSO "BUNKO") KELLEY[55]

Joe Kelley was a squat, barrel-chested man with a dark complexion, an oversized nose and a scrubby mustache. He wore a scuffed-up derby hat and usually had an unlighted cigar stub protruding from his lips. He came into Portland with his brother, William, sometime in the mid-1880s and started working as a "runner" for sailors' boardinghouses and doing a little "shipping sailors" on his own. His first mention in the *Oregonian* is in February 1887. A local printer named Fulton was missing, and Kelley was going around saying that Jim Turk had shanghaied the man. Turk, in turn, sued Kelley for liable. When a reporter from the *Portland Telegram* asked Kelley about the suit, he was quoted as saying, "Sometime when you are not in so great a hurry I will tell you more about the goings on of the pirates of this port."

Two months later, Kelley was back in court; this time he was the plaintive, suing the captain of the bark *Arica* for refusing to pay for a sailor Kelley had provided. On its way to sea, the sailor had been taken off the *Arica* in Astoria by the sheriff to answer to the charge that he owed money to an Astoria crimp. The agreement Kelley had with the captain of the *Arica* read: "Please pay bearer, Kelly, $70 for getting a man, provided such man will sail over the bar." Reason seemed to side with the *Arica*, but Justice Tuttle of the United States Circuit Court in Portland sided with Mr. Kelley and ordered the $70 paid.[56]

Soon after the limelight hit Mr. Kelley for being the winner in this suit, he was once again in the news. The unhappy captain of the British bark *Jupiter* sent a letter to the editors of the *Oregonian* as his vessel sailed from Astoria.

Thirteen Years in the
Oregon Penitentiary

By Joseph (Bunko) Kelley
Portland, - - Oregon
1908

JOSEPH KELLEY

Frontispiece of Bunko Kelley's self-published prison memoir, *Thirteen Years in the Oregon Penitentiary*.

A Shipmaster's Complaint
Astoria, April 14, 1887
To the Editor of the Oregonian:
Allow me a few lines in your paper to let shipmasters know how I was
swindled in Portland by "Bunco" Kelly shipping a man on board of my
ship, a perfect cripple by rheumatism. The man did no work on the ship …
for the whole passage.
Thomas Jones
Master, Bark Jupiter

Before this letter, the name "Bunco" Kelley had not been used. The captain may well have coined a name that would go down in infamy. "Bunco" Kelley stuck as tightly as a battened hatch in stormy weather. Kelley, delighted to have notoriety of any sort, wore the name as a badge of honor for the rest

of his days. And "Bunco," the sinister shanghaier who was too slippery for the law, was happy to inflate his shenanigans to the level of a Baron Von Munchhausen, whose fanciful escapades were serialized in the newspapers of the day.

In later days, Edward C. "Spider" Johnson, a man who claimed to have been around in the shanghaiing days, would spin these tales in Erickson's Workingman's Club and Saloon on Third and Burnside for the enjoyment of Stewart Holbrook, a logger whose "rough writer" stories had brought him a large audience of readers. Holbrook fed on the yarns of old miners, loggers, punched-out boxers, arthritic sailors, winos and prostitutes in what was left of the dives of the north end. The stories he heard he polished up on his typewriter and sent off to eastern publishers, like the *Atlantic*, H.L. Mencken's *American Mercury* and the like. It was through Holbrook that the tales of Spider Johnson entered into the mythology of Portland as undisputable fact, even to be repeated in some history books.

Spider Johnson's tale of how Bunco got his name goes like this: Joe Kelley, the shanghaier, needed a sailor to round out a crew for a vessel that was departing. Not finding anyone, he went over to Wildman's Cigar Store at First and Glisan[57] and stole the wooden Indian from the front, wrapped it in tarpaulin and sold it to the ship's captain for fifty dollars. Later on, the Indian was seen bobbing in the Columbia River and was returned to Mr. Wildman's store, where he chained it to a post to deter such activity in the future. This tale is the least fanciful, and therefore the most believable, of the Bunco Kelley tales. However, it has no supporting evidence from the period.

One of the more Munchhausen-like stories repeated by Holbrook was about a ship called the *Flying Prince*. It lay alongside a lumber dock, loaded with lumber for China, but in need of thirty-nine[58] crewmembers in order to sail. (Stewart Holbrook later claimed twenty-four; others vary the number from seven to thirty-nine according the gullibility of the audience.) Bunco and his runners went through all the dives and dens of the north end, but not a shanghai-worthy person was to be found. As fortune would have it, thirty-nine (or whatever number was needed for a good story) winos found their way into the basement of what they thought was a saloon to drink their fill of the house rum stored there in barrels. They cracked open a barrel containing some sort of liquid and merrily drank their fill, not realizing that they were in the basement of the undertakers and were imbibing embalming fluid.

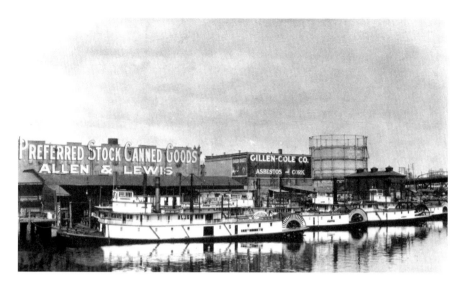

Allen and Lewis dock and city gasworks near the Burnside Bridge, in the "Whitechapel" district, circa 1900. *Copyright Thomas Robinson.*

As fate would have it, one of Bunco's runners heard a low moaning sound coming from below the dive he was visiting. Upon closer investigation, a congregation of expiring winos was discovered. Bunco, resourceful crimp that he was, wasted no time in wrapping all of the unfortunate fellows each in his own tarpaulin. He trotted them off to the lumber dock where the *Flying Prince* sat waiting. Bunco convinced the master of the ship that these moaning creatures wrapped up in tarps were all actually drunken sailors, who would make fine seamen once they woke from their slumbers. That evening the *Flying Prince* set sail (how it did so without a crew is undetermined). We may all well imagine the captain's surprise when, in the first light of dawn, instead of finding a crew of hearty sailors, he found thirty-nine corpses. One can only hope he did not fling them over the side into the Columbia River, as was done with Mr. Wildman's Cigar Store totem. Here are the exact words of how Spider Johnson ended his tale in an interview in the *Oregonian*: "The Skipper paid the $52 and the schooner sailed for Astoria, and other ports with 39 corpses aboard. No I don't know positive that that story is true, but it's one you'll hear from any of the old-timers. There were strange things that happened. No, I don't know where the ship went with 39 stiffs for sailors."[59]

For the sake of those unlearned in the ways of the windjammers, Captain Brodie (quoted earlier) went around the Horn over forty times

with a crew of nine men. One of the largest ships to visit Portland in those days, the four-masted schooner *Europe*, had a crew of twenty-four (not counting the officers). I am certain that both Spider Johnson and Stewart Holbrook got a kick out of how gullible listeners would actually believe this preposterous tale. However, I do admit the story is a fine yarn to spin while sipping a pint with out-of-town friends in one of the remaining watering holes in Portland's "Old Town." Of course, we must add a bit of "wink, wink, nudge, nudge" lest we appear gullible enough to believe the tale ourselves.

The "real" Bunco Kelley claimed to have been born in Liverpool and everyone (including the writers of history) took him at his word, but it appears that he lied about this detail as well. He was sent to the Oregon State Penitentiary in 1896 for a murder charge we will examine later, and the official record given by the penitentiary to the 1900 United States Census records that he was born in 1846 in Connecticut and that his father came from Ireland. In his autobiography, Kelley claims to have fought in the American Civil War, an uprising in Cuba and the War of the Pacific in Chile; he also claims to have been shipwrecked in the islands of cannibals where he was forced to snack on his shipmates and to have traveled all over India observing—like a foreign correspondent— the abuses of the powerful British. All this he supposedly did before coming to Portland!

BUNCO, THE LOWLY CRIMP

Joseph "Bunco" Kelley was the kind of crimp who gave the business of "shipping sailors" a bad name. It would be hard to call him a sailors' boardinghouse keeper since he never seemed to actually have a boardinghouse, at least not one with an address in the Portland City Directory. He had none of the finesse that went along with being a first-rate figure of the underworld. He had none of the presence and charisma of Mrs. Grant, in Astoria, and none of the class of her elegant sons, Peter and Alex. Kelley was definitely outclassed by Larry Sullivan who—in his three-piece suits and diamond-studded cuffs—rubbed shoulders with senators. Even Jim Turk, freshly shaven, smelling of expensive cologne and Cuban cigars, could be seen as someone having authority. Bunco, on the other hand, was a cheap man who

could make even an expensive suit look cheap. He smoked nickel cigars and slept in cheap rooms. He was a "blow hard" who told "fish stories," and worst of all, his word was worthless. As a compulsive liar, he had told marvelous tales about himself to drunken audiences in dozens of dives and blind pigs (unlicensed saloons). What made this situation even worse is that some of the winos and souses believed him. Some people even spoke his name with a kind of awe.

The Portland and Astoria sailors' boardinghouse firm of Sullivan, Grant Bros. & McCarron and the firm of James Turk were mostly harmonious and did not interfere with each other. Bunco was another matter. Although the other crimps found him useful on occasion, Bunco had a way of irritating those he worked with, often to the point of violence.

BUNCO IN THE HOOSEGOW

One of Bunco's other interesting traits was that he was paranoid. Although paranoia is a mental disorder, it is not always unfounded. He often worried that the other crimps were in cahoots to put him permanently out of business. Not having an establishment of his own, he seemed to work more like a parasite on the other crimps. By 1893, he was working for Larry Sullivan as a runner, as can be seen in an interview in court, under oath, when he said he was "in partnership with Sullivan." The fact that Sullivan treated him with open contempt does not support the "partnership" part of the statement. It is unclear who was involved in the conspiracy to get rid of him, but the man with the most brains and influence was Larry Sullivan.

In the early morning of October 5, 1894, the body of a man was found floating in the Willamette River between Ainsworth and Mersey docks just north of the Albina Ferry landing. A patrolman was summoned to the scene, who, with some difficulty, roped the corpse to a wharf piling and sent for the coroner. It turned out that the dead man, who had received six deep gashes to his skull before being tossed in the river, was a seventy-three-year-old man named George Washington Sayres. He was a man well known to law enforcement officers as a former saloonkeeper. At the time of his death, he was involved with Bunco Kelley in a foolish, lowbrow scam to sell bogus opium to some inhabitants of Chinatown.

Police Chief Minto spent no time in rounding up a crew of suspects composed of lowlife associates of the dead man. This group included Bunco Kelley, Paddy Lynch and four or five other ex-convicts, smugglers and thieves. They were hauled into the police station, where they immediately found themselves subjected to the severe interrogation techniques of District Attorney Hume. Later on, the dead man's wife, an old woman who called her husband "Mr. Sayres," told the police that after dinner that night, her husband had said that he was going to meet Bunco Kelley, who had promised to loan him some money to get by until a lawsuit he had cooked up came through.

Each of the group of suspects had a conflicting story to tell. One, a half-witted old sailor who had been living at Kelley's house, claimed that Kelley had given him a "slungshot"[60] and had told him that he should kill Sayres with it—that there was $5,000 to be divided should he do so. Kelley denied any knowledge of the murder and any indication that he had met Sayres that evening. His alibi was that he was in a fistfight with Larry Sullivan that evening, which explained the bruises that he bore. Sullivan failed to support this alibi or lift a finger to help his "partner." Bunco was charged with the murder, along with one of Portland's more vicious hoodlums, an ex-convict named Bob Garthorne who was seen as an accomplice. The rest of the motley assortment was jailed as material witnesses.

Minto and Hume's biggest problem in pursuing Bunco Kelley was the complete lack of motive. Besides this, it was well known that Bunco was not the sort of fellow to let a nickel get past him unpocketed, and Mr. Sayres still had his gold watch and some jewelry on his person when he was fished out of the Willamette. At the time of his murder, Sayres was involved in several large lawsuits against a former business partner. The fact that this former partner was never put beneath the lamp of scrutiny in the interrogation room is indeed interesting. He seems to have been a man the authorities considered above reproach. A few days after the murder, District Attorney Hume had Bunco's lawyer, a man with the inhospitable name Xenaphon N. Steeves, arrested for complicity in the murder.

These being the days of trial and conviction by newspaper, the October 9 *Oregonian* carried the heading:

Garthorne Struck the Blow.
"Bob" Garthorne, who is known to be one of the most vicious vagabonds that ever infested Portland, is believed to be the fiend who struck the blows that ended Sayres' life. "Bunco" Kelly was undoubtedly present at the time,

and gave valuable assistance in overpowering the old man while his brutal companion crushed the victim's skull.

The nonstop sensationalism of the press, combined with a general dislike of Bunco Kelley, overshadowed the absence of a logical motive and the insistence by Kelley that he had an alibi for the night of the murder, if they would just check it out. Then, in the midst of the trial, two local lawyers were arrested for attempting to bribe a juror to give a not-guilty verdict. Had there been any doubts in the minds of the good men and women of Portland, they were there no longer. Bunco's goose was cooked.

On February 10, 1895, Joseph "Bunco" Kelley was convicted of the murder of George Sayres. Before the sentence was pronounced, Judge Stevens asked if Mr. Kelley had anything to say, to which he replied: "This whole thing is a job of Detective Welch and Larry Sullivan. I had nothing whatever to do with the murder of George W. Sayre." When the judge then pronounced that he should spend the rest of his natural life in the Oregon State Penitentiary, Bunco replied, "I would rather be hanged." Judge Stevens answered wearily, "That is all."

When the Overland South train containing the prisoners bound for the penitentiary stopped at the Salem railroad depot that evening, a crowd of spectators had gathered hoping to get a glimpse of the infamous Bunco Kelley. The fact that Bunco had none of the charisma and presence of some of his fellow murderers is made clear by a pathetic report in the Salem *Capital Journal*. "It was evident from the confusion and disappointment manifested, that misapprehension regarding Kelly's physical development, was general; everybody expected to see a big, brawny double-fisted desperado, and as none of them answered such a description the crowd seemed inclined to repudiate the idea that the criminal was there: but he was."[61]

The Oregon State Penitentiary in Salem at that time resembled the Soviet Russian gulags that would appear in later years. It was a place of scourging with whips and bashing of heads by murderous guards—a place even less hospitable than the "hell ships" to which Bunco Kelley had sent so many souls to suffer. Bunco would spend thirteen miserable years behind those stone walls in Salem before being pardoned by Oregon governor Chamberlain. The governor was made aware that a frame-up had been perpetrated on Mr. Kelley. Something must have come to the surface after Bunco's conviction that convinced prominent Portlanders of his innocence.

A drawing of Bunko Kelley languishing in prison. *Morning Oregonian* (January 7, 1895).

A petition for his release—although not made a public record—was said to contain the names of several important citizens. Even District Attorney Hume signed the petition for his release. When signing his release papers, the governor never said that he was an innocent man, only that he had spent enough time behind bars.

Once out in the fresh air again, Bunco wrote a book chronicling his experiences called *Thirteen Years in the Oregon State Penitentiary.* The book was a detailed account of the insults and injuries inflicted on the prisoners by guards who were accountable to no one. Bunco had many reasons for publishing this book, and it is almost certain that one primary reason was to call attention to the intolerable condition of the hellhole. But it is also certain that he thought that he could cash in on his minor celebrity status. When he was on trial, the entire state was spellbound for weeks. Now that he was out, and with a story to tell, he filled suitcases with copies of his book and went on tour up and down the coast, hawking his book in whatever grange hall or saloon would have him. Thirteen years, however, is a long time, and most folks had either never heard of him or had forgotten about him.

Today his book is especially interesting for its colorful language—the jargon of a poorly educated nineteenth-century American who had been around sailors most of his life. Not only did he include tales of the penitentiary days but also bizarre tales of being a sailor shipwrecked among the cannibals of the South Seas and other stories such as a perpetual liar named "Bunco" would be expected to tell. What he failed to include in his book was his experiences as a sailors' boardinghouse runner in the north end of Portland, Oregon.

What became of Bunco Kelley? He surfaced briefly in San Francisco in 1908 working as a flunky's flunky for San Francisco's most infamous gang boss, Abe Ruef. The gangster was on trial for bribery, and it was his custom to fill the courtroom with his strongmen as a tactic of intimidation. Among those listed in the crowd was Bunco Kelley. The report reads: "Bunco Kelly, another undesirable, who openly reports to Ruef's office boy, Charley Haggerty, during recesses of the court, was also present."[62]

This seems like a very plausible job for Bunco. The sailors' boardinghouse racket was nearly over by that time, and he moved in underworld circles. Another small piece of evidence to point Bunco in the direction of California was a remark by Spider Johnson, who said that California was where Bunco had gone. From here, he drops out of sight forever.

LARRY SULLIVAN OF THE FIRM SULLIVAN, GRANT BROS. & McCARRON

The profession of sailors' boardinghouse master required a certain degree of physical strength and dictated that the practitioner be a loud, rude and insensitive bully. This tended to draw individuals from areas requiring similar skills and assets. Larry Sullivan was a pugilist who came to Astoria from Pittsburg, Pennsylvania, in 1885. His distant relative John Sullivan was the world-champion boxer who was as famous in the nineteenth century as Mohammed Ali was in the twentieth. When Larry began to take a beating in the boxing ring, he decided to try his hand doing something easier and more lucrative—shipping sailors.

Astoria was as important a location for shanghaiing as Portland, for during certain months it seemed as though Astoria was indeed the port city of Portland. When vessels chartered to receive cargo at Portland ended up getting no farther than Astoria, the boardinghouse masters of Portland needed to go to where the sailors were. In Astoria, Sullivan had become fast friends with some of the Grant brothers—Peter, Alex and Jack—young men who had grown up in the crimping trade. When their father was killed in a freak accident, their mother, Bridget Grant—a strong woman of beguiling beauty—took over the sailors' boardinghouse business.

The first Sullivan and Grant Bros. establishment was in the cannery section of Astoria. There is strong indication that they were able to operate in conjunction with W.J. Barry, the chief of police at the time, assisting him in ridding the town of people he considered undesirable by shanghaiing them for parts unknown. One such case came to light when a man named Norris disappeared. Many months later, he appeared in France. The story came out that he had been arrested by Barry for an imaginary murder, but instead of being arraigned, he was shipped off to sea with the help of the local boardinghouse masters. The papers he was forced to sign were not just ship's papers, but the attorney Barry had provided for him (a man named Campbell) had also supplied, among the other papers, the deed to Norris's property across the river in Washington Territory. The property became Campbell's, Norris became a sailor, Sullivan received the blood money and Barry was rid of an undesirable.

The Grant brothers learned the art of molding and intimidating politicians in the small seaport town of Astoria. With Sullivan on board,

The first Steel Bridge and docks near the Sullivan, Grant Bros. & McCarron Sailor's Home, circa 1888. *Copyright Thomas Robinson.*

they felt they could do better, and they lifted their eyes to Portland. By the early 1890s, Sullivan and the Grant brothers operated from an establishment called simply the Sailor's Home. This was in Portland's north end on the southwest corner of Second and Glisan Streets, across the street from the Northern Pacific roundhouse. According to Spider Johnson, there was nothing "swell or gaudy" about the place—it was just an old warehouse. "It had everything in it but bats flying around." They brought with them from Astoria another man, Richard McCarron. McCarron was a street tough who had been crimping on his own since early in the 1880s.

Sullivan, Grant and McCarron retained a cooperative relationship with the Grant brothers' mother, Bridget. She ran an establishment in the business district of Astoria that appeared to be so respectable that it could be mistaken for a small hotel. Appearances can be deceiving. She had her own methods of enticing landlubbers to go to sea. She also ran a farm out in

Horses drinking from the Skidmore Fountain, a centerpiece of the city's north end, circa 1905. *Copyright, Thomas Robinson.*

the forest several miles from Astoria where she could keep sailors busy—and working—while they were being hunted by authorities.

The Grant boys, with their good looks and style, could have easily passed as wealthy business owners, whereas Larry Sullivan, like his rival Jim Turk, was large and brutishly handsome. The boys had also been taught by their mother to avoid liquor and gambling. Sullivan, on the other hand, was given to bouts of drunkenness, and he was fond of punishing his detractors with his oversized fists. His name repeatedly appeared in the police rosters and the newspapers as he was arrested for various degrees of assaults, murder threats and attempted murders—charges that rarely stuck and never brought the kind of penalties that would have been appropriate to the crime but rather "slaps on the wrist" and fines. In spite of his brutishness, Larry Sullivan was calculating and highly intelligent. He rose to be a towering presence, not only on the waterfront and in the dives of the north end but also in Portland politics.

The Sailor's Home was firmly situated in Portland's north end, a place the newspapers had started calling "Whitechapel." It was the part of town where honest businesses were hard to find, and honest citizens passed through nervously on streetcars as they made their way to the railroad station or ferry terminals. Having a large population of gamblers, pimps, prostitutes, bunco men, winos, foreign sailors and crooks at his disposal, Larry went into politics. Although in later years Sullivan came just a few votes from being on the city council, he was not a politician himself but a "king maker," someone who could get ballot boxes stuffed full of votes for the right candidate. From this position of power, Larry could get around a lot of inconvenient laws. He was the Republican party's "ward captain" for his district, Ward 2.

Besides the Sailor's Home, the firm acquired the prestigious Portland Club. This was the sort of place where wealthy businessmen were not ashamed to be seen. The club was on the northeast corner of Fifth and Alder Streets, next to a Chinese gambling joint and a place where chickens were butchered. Though Larry operated from the north end, he built a fine residence among the other Nob Hill mansions on the southwest corner of Eighteenth and Irving, a place from which his wife could entertain the ladies of society[63] and he could smoke cigars with the chief of police.

Larry was still fit and was still willing, even in the 1890s, to step into the boxing ring. In those days, boxing was of far more importance than it is in today's society. In a world before radio and television, it was a major

Larry Sullivan. Courtroom sketch, *Morning Oregonian* (November 15, 1904).

form of entertainment, and the notoriety associated with boxers can only be compared with rock stars in today's world. Larry loved the limelight, loved to be pointed out as he walked down the boulevard and, most of all, he loved to be feared. He, like the unpleasant Mr. Turk, was always itching for a good street fight.

Sullivan's version of the game was to eliminate competition and to own politicians. Eliminating the competition often took the approach of physical contact. Jim Turk certainly must have come to some understanding with Sullivan's firm early on. There is no mention of friction between the two operations. However, other upstarts and hoodlums with the audacity to enter the game often found themselves in a great deal of physical discomfort. Paddy Lynch had been Jim Turk's runner at one time, but when he dared step out on his own, encroaching on Sullivan's territory, he found himself in St. Vincent's Hospital with his teeth missing.

Larry Sullivan was unfazed by the majesty of authority when handing out punishment. One evening in May 1895, Sullivan was drinking at the Trivol, a saloon and theater in the north end, when U.S. district attorney Daniel R. Murphy entered the establishment. Sullivan began to berate Murphy over a conviction he had been successful in prosecuting against someone named James Lotan. Sullivan became so riled by Murphy's remarks that he jumped on the official and began to beat him about the face, causing "savage injury."[64] Sullivan was arrested and allowed to cool off in the Central Station lockup. Instead of facing years in the penitentiary, as would be expected after such a serious offense against an officer of the court, Sullivan was released the next day.

Leaving the police station, Sullivan proceeded to a nearby saloon and immediately drank himself into a blind rage. In the company of a friend, Sullivan left the saloon whereby he happened on a passing banker, a Mr. Quinton MacPhall of the London and San Francisco Bank. Without provocation, Sullivan jumped Mr. MacPhall, beating him and choking him viciously. Sullivan was once again taken to the police cooler, only to be set free later.

Larry Sullivan and Peter Grant were both supporters of Joseph Simon for the U.S. Senate. During the Republican primaries of 1896, Sullivan set up the ballot box for the Second Ward in his sailors' boardinghouse, while Peter Grant oversaw the election at the Third Ward, a few blocks away. When the supporters of Simon's opponent, J.H. Mitchell, complained to the police that all manner of hobo and foreign sailor was voting in the north end, the police headed north. When they entered the

sailors' boardinghouse polling station, they were confronted by Larry Sullivan with his shotgun, who promised to kill the first man who laid a hand on him or the ballot box. One paper said that honest taxpayers were kept from the polls by a "vast mob of heelers, thugs, vagrants…with business men sandwiched in between hoboes and morphine fiends."[65] There were dirty politics on both sides, and scandal left the Senate seat vacant for two years.

The district attorney wasn't the only official Sullivan assaulted physically and in public. On December 8, 1892, the following appeared in the *Oregonian* under the heading "Beaten by a Tough."

> *Last night about 9:30 o'clock, as Officer Snow approached the corner of Third and Burnside streets, he saw Larry Sullivan, a sailor boardinghouse runner and slugger sitting astride of a man and trying to pound him into insensibility. The man underneath proved to be Harbor Officer John J. Byrne.*

It came to light that the harbormaster had attempted to arrest Sullivan for harboring sailors. Later that evening, Bunco Kelley came down to post Sullivan's bail, as an act of either bravado or obeisance. Why Sullivan was never imprisoned for these continual outrages is sufficient proof of the "pull" he commanded, even at the highest level in the Oregon judicial system. This pull extended into the Oregon legislature as well. A good demonstration of this is an event that took place on Christmas Eve 1903. An anti-gambling faction in the Oregon state legislature managed to pass a collection of bills forbidding gambling and restricting and regulating games of chance and lotteries. The bill managed to disappear overnight, like snow in the sunshine. On New Year's Day, the *Capital Journal* commented, "The religious members of the house passed a gambling bill. The Larry Sullivan crowd came up from Portland, and the bill was 'seen to' before it ever got to the senate. That august body never had the privilege of even looking at the bill."

After Bunco Kelley was removed from the scene, Sullivan turned his eyes toward some newcomers and thorns in the side, Smith and the White Brothers. This was the Albina sailors' boardinghouse crew made up of the famous boxer "Mysterious" Billy Smith and brothers Harry and Jim White. Even though their place was across the river, that was, in fact, where much of the business was located—the grain docks of Albina. For a brief period, the two firms formed a consortium, a move

Peter Grant. Courtroom sketch, *Morning Oregonian* (November 15, 1904).

that worried the business community for its potential to drive up the price of shipping. But it wasn't long before they were at each other's throats, using the police and the courts against each other and accusing each other of "shanghaiing," attempted murder and any other charge that might put a freeze on competition.

These battles continued until suddenly, in 1904, sensing that the "wide open" era in Portland was coming to a close, Larry Sullivan sold out his interests in the Portland Club and the Sailor's Home. He was also said to be the owner of oyster beds, fishing grounds, canneries and mines. The following year, he was nominated by the Republican party to run for the Ward 2 position on the city council. In an *Oregonian* article of May 10, 1905, he promised that, if elected, he would provide free schoolbooks for

the children of his ward. "I'll buy the books if I go broke, but I will not go broke," Sullivan was quoted as saying. It would be hard to go broke buying books for the schoolchildren in a ward of the city comprised of single men in lodging houses, saloons, bawdy houses and gambling dens. He lost this election by just a handful of votes.

After losing the election, Sullivan pulled up stakes and moved to Goldfield, Nevada, where he became involved in one of the greatest bunco schemes ever perpetrated—a multi-million-dollar mining and banking concern that bore the name Sullivan Trust Company.[66] After this company crashed, Sullivan became entangled with a shady operation in Los Angeles that was shut down by federal agents.

When Larry Sullivan finally returned to Portland in 1916, he was broke and terminally ill with chronic nephritis—a painful disease of the kidneys. He was by then estranged from his second wife, Lucille Ayers, although she called herself "Mrs. Larry Sullivan," when she was arrested for running a house of prostitution. Somehow, by December 1916, Sullivan was able to scrape together enough money to go into business with a former saloon owner. Together they purchased a dance hall called Friar's Club. The plan, it was said, was to turn it into a "café" with dancing. These were prohibition days in Oregon (Oregon went dry in 1915), so it was no surprise to anyone when, two months later, the Friar's Club was raided for breaking liquor laws. Soon Sullivan was in trouble with the law, and he found himself being sued by his partner for "misappropriation" of $500. It must have been an insult to whatever was left of Sullivan's dignity to find himself in hot water over such a trifling amount after having had millions run through his fingers.

In August 1917, Larry Sullivan was convicted of bootlegging, fined $250 and, for the first time in his long and wealthy career of corruption and vice, was facing a jail sentence of thirty days. Two men then took pity on the fallen kingpin: the owner of the Foundation Shipyard, who offered the penniless Sullivan a job, and the governor of Oregon, who commuted his sentence under the condition that he pay the fine as soon as he was able. Sullivan would pack his lunch bucket and go to work with the rest of the stiffs for as long as he was able. At 7:00 p.m. on June 8, 1918, as twilight fell through the curtains of his room at St. Vincent's Hospital, Larry Sullivan died. He was fifty-five years old.

"MYSTERIOUS" BILLY SMITH AND THE WHITE BROTHERS—CHAMPION OF THE WORLD

It would be interesting to speculate as to why the first person to be recognized as the welterweight champion boxer of the world, at the height of his career, would want to establish himself as a sailors' boardinghouse master in Portland, Oregon. It may be that he saw the rather enviable position of wealth and political power enjoyed by Larry Sullivan and thought that he could do as well himself. It is fairly safe to assume that his managers and handlers kept so much of "Mysterious" Billy Smith's boxing take that he was on the lookout for ways to make some money on his own.

This man who became famous as "Mysterious" Billy Smith was born Amos M. Smith in 1871 in a small town in Nova Scotia. He left home in his early teens and was boxing professionally by 1888. He had passed through Portland a number of times before settling here, and his boxing associations certainly meant that he was often in the company of figures of the underworld. By 1902, he was in business with Jim and Harry White, two brothers with a sailors' boardinghouse close to the grain wharves in Albina.

The White brothers appear, at first, to be in a sort of partnership with Sullivan, Grant Bros. & McCarron. It is interesting to note that the first mention of "Mysterious" Billy Smith as a crimp was an article in the business section of the *Oregonian* under the heading "May Advance Rates: Rumor That Sailor Boarding-House Opposition Is to Be Absorbed." The article then speculates that a partnership between the crimps was likely to raise the shipping rates affecting Portland.[67]

The partnership with Sullivan did not last long, and open war was declared, a war that played out in the streets and in court. By February 1903, "Mysterious" Billy and the Whites were facing charges of kidnapping involving a British sailor. Reading between the lines of news reports, it looks like the British vice consul, Laidlaw, was tipped off to the affair (most likely by one of Sullivan's men). Laidlaw had been wanting to make some move against the crimps besides writing heated letters to the editor. In these newcomers, he saw a chance to bring down the force of the law, without facing an imminent threat to his own well-being, such as would occur should he try to challenge the Sullivan faction. Laidlaw personally made the complaint against them and swore that

"Mysterious" Billy Smith, World Welterweight Champion, 1892. He was called the "dirtiest fighter of all time." *From an unmarked card, presumably a sports card, dated 1897. Author's collection.*

he would "spare no expense to prosecute the case." It is possibly not a coincidence that the very day that "Mysterious" Billy and the Whites were charged, the Oregon State House of Representatives passed a law requiring that sailors' boardinghouses be licensed and regulated by a commission. "Mysterious" Billy and the Whites challenged the law in court and continued operations, unlicensed.

When the kidnapping case fizzled out in this heated environment, another accusation soon flared up. This time Sullivan, Grant Bros. & McCarron were able to use the fact that the Albina firm was unlicensed as leverage to steal away its business.

One hot afternoon in late August 1903, "Mysterious" Billy and the White boys were heading up Front Street after having just been involved in a violent argument with the clerks at the offices of James Laidlaw. This was the office that was in charge of assigning sailors to British vessels docked in Portland. "Mysterious" Billy and the Whites had been cheated out of some of their "clients" by the Sullivan people, but the British vice consul would give them no redress due to the unlicensed nature of their business. As they climbed the stairs on the Steel Bridge, they saw two of the Grant brothers escorting several sailors to the grain docks, the very sailors who had been staying with them at the Albina sailor's home and whose "blood money" by rights should have ended up in their pockets. Accusations and threats flew, and "Mysterious" Billy rushed at Jack Grant with his fists clenched. The *Oregonian*, in a lame attempt at humor, described the scene thus:

> *Now "Mysterious Billy" Smith once had a reputation as a fighter. Since he smashed his hand on the adamantine surface of Joe Walcott's head he has lost most of it. But he still has a name as a street fighter and a bad man to mix with. Mr. Grant says he is a peaceable citizen and lays no claim to a record of ringside victories. So the picture of Smith with blood in his eye was not attractive to Mr. Grant.*[68]

At that point, Jack Grant pulled a gun. The accusations and curses continued to fly, but eventually the "Mysterious One" (as he was sometimes called) backed off, "smarting from the indignity of being called a quitter" and headed to the office of District Attorney Manning to swear out a complaint against Jack Grant.

The next day, all these lads, along with Larry Sullivan, were brought before Justice of the Peace Reid. What unfolded is a courtroom drama such

as would be expected in Tombstone or Leadville. The expletives and threats were heavy in the air, as the reporters, all suppressing the urge to chuckle, scribbled hastily on their notepads. When "Mysterious" Billy demanded that Grant meet him "man to man," Grant's attorney quipped, "Do you think that, brute and bully which you are, that other men are going to meet you with their hands?"

Mr. Grant had never presented himself as a fighter and said as much, so "Mysterious" Billy's posturing didn't seem to swing much weight with anyone present. Then Harry White took the stand and began to boast as to how "Mysterious" Billy had offered to thrash all of the Grant brothers crowd and how he dared the coward Jack Grant to fire his gun. After another period of cursing and threats, Jack Grant took the stand.

> *I had the gun, and I intended to use it, and I still intend to use it on him if he ever tries to harm me. I declare right here in open court that, just as sure as he makes a move, I'll fix him up proper. He is a dirty cur, and he will never put his trademark on me. I would not have the slightest hesitation in killing him. I have a loaded revolver in my pocket right now.*
>
> *One of these fine days Smith will get drunk, and then he will look me up like a little terrier cur—and then it will be a busy day for Smith.*
>
> *I'll tend to Smith whenever he comes. I don't like to carry a gun, because it wears out my clothes, but I must have protection, and I am no match for Smith in a fight, even if I am the biggest man.* [69]

After all the excitement, the threats and the insults, the justice of the peace made his pronouncement on the case before him, the attempt by Jack Grant to murder "Mysterious" Billy Smith. "This is a case which should never have been brought into this court. They had a little row among themselves, and should have let it go at that. I can't conclude that Grant was unjustified in what he did. The defendants will be discharged." [70]

It had come to light in the trial that the Sullivan and Grant company had paid the captain of the ship whose prospective crew was coming from Albina to switch his business to them. Since the death of Jim Turk and the demise of Bunco Kelley, Sullivan, Grant Bros. & McCarron had almost completely owned the game in Portland. They had smooth dealings with the authorities, and everything ran like clockwork—a clock that gave James Laidlaw a sour stomach. "Mysterious" Billy and the Whites were trying to get into a game that was already sewn up. They must have thought that Sullivan would allow

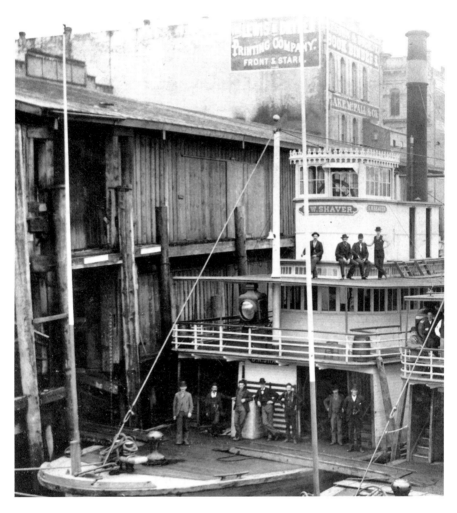

Steamboat men of the Shaver Transportation Company at the Shaver Dock north of the Morrison Bridge, circa 1890. *Copyright Thomas Robinson.*

them to run the game across the river at the Albina docks, but apparently that was not the case.

In December of that year, the Oregon Supreme Court heard the case brought by "Mysterious" Billy and the Whites against the Sailors' Boarding House Commission and its decision to grant a monopoly to Sullivan, Grant Bros. & McCarron.[71] The next month, the court ruled that the commission had no right to grant a monopoly to any firm. The headlines shouted:

> *SHORN OF POWER*
> *Boarding house commissioners are disgusted,*
> *The Price of Tars May Go Up*

In the same article, in an obvious reference to the immaculate gangsters Sullivan and Grant, James Laidlaw was quoted as saying:

> *One set of crimps is no better than another, then why grant one set a monopoly? If one set struts in immaculate linen and fine clothes and lends its presence to the State Legislature, that does not prove superiority: in fact, it doesn't make any difference so far as I can see.*[72]

Even though the Albina sailors' boardinghouse was allowed its license, the demand for sailors was declining. Within a few months, Sullivan had left for Nevada. "Mysterious" Billy diversified his meager income sources. He leased a tavern just off Burnside Street in the north end, the Atlantic Saloon at 61½ Third Street, and he continued to box professionally. His long winning streak was over, but his name continued to draw crowds, even if it was to see the one-time unbeatable Billy beaten. All was not well on the home front either for poor Billy. His wife, whom he accused of being a drunk, left him to attempt to run a lodging house on her own. Possibly to beat her to the punch, he filed for divorce, something that became an ugly public spectacle. She retaliated by accusing him of infidelity and of failing to support her. As a result, the Atlantic Saloon was shut down by the court, the judge stipulating that it could only reopen if "Mysterious" Billy complied with the spousal support order.

"Mysterious" Billy Smith was a fighter in more ways than one. Somehow he managed to make it through prohibition in Portland, after which he spent the remainder of his days as the owner of one of Portland's most colorful and well-loved watering holes, a beer parlor at 1500 North

Wheeler (in Albina) that he named the Champion's Rest. He was laid to rest October 14, 1937, marking the very end of this strange period of Portland history—one that has rarely found its way into the history books, even though there is a seemingly endless depth of material to draw from, should someone start looking.

THE SEAMEN'S FRIEND SOCIETY

Quite early on, the foremost citizens of the city recognized the evils being perpetuated against sailors by the boardinghouse game. Most of these men had been instrumental in forcing through the legislation required to start the processes of perpetually dredging the 113 miles from Portland to the sea, to ensure the success of the dream of Portland as an inland seaport. Years earlier, in 1864, they had reached into their own pockets to purchase a dredge for $24,000. They turned the dredge over to the U.S. Army engineers and used what influence they had to attempt to develop a narrow, crooked channel, twelve feet wide and seventeen feet deep. By 1877, they had influenced the U.S. government to adopt a plan to dredge the channel to a depth of twenty feet—although it would be years before this goal was accomplished.

These men began to develop a project to address the hardships of the lowly sailor. In November of that year, the city's most prominent business leaders, along with James Laidlaw, vice consul for the British crown; Captain N. Ingersoll; and H. Hewett, vice consul for Sweden and Norway, gathered to form a Portland chapter of the Seamen's Friend Society. The bylaws, published in the City section of the *Oregonian*, December 1, 1877, stated: "Its object is to promote the temporal, moral and spiritual welfare of seamen, steamboat men and longshoremen, by establishing a Mariners' Home and Church, to be conducted on strictly temperance and non-sectarian christian (sic) principles."

The Seamen's Friend Society of New York sent a Methodist Episcopal preacher from Saint Louis named R. S. Stubbs to help in these efforts. These men saw sailors as men enslaved by their passions and circumstances and too weak to fight against the forces of evil that conspired against their souls; therefore, it was necessary for those of privilege and honor to step in to save them. Later, in his *History of Portland*, *Oregonian*, editor Harvey Scott would

write, "Here, as everywhere, the contention is against the very powers of darkness, for, the world over, the foes of 'poor Jack' are relentlessly cruel: cupidity and greed are their chief characteristics, and to these the sailor boys, through innocence or passion, fall an easy prey."

THE BETHEL FLAG

Mr. Stubbs was sent to hoist the bethel flag over Portland's waterfront. Since the early part of the century, evangelical and temperance-minded Christians had been erecting bethels, or mariner's churches, in seaports around the world. Where there was no physical bethel, wherever seamen gathered together to pray and worship, a bethel flag was raised, whether in some chapel ashore or in the sailors' mess aboard ship. The constitution of the American Seamen's Friend Society declared the object of that society was to "improve the social and moral condition of Seamen, by uniting the efforts of the wise and good in their behalf." Besides building a bethel, the members were to try to build "boarding houses of good character, savings banks, libraries, reading rooms, etc."

The first bethel meeting in Portland was Sunday, November 4, 1877, aboard the *Earl of Granville*, at Flanders' Wharf. With one of those twists of irony thrown out by providence, the second meeting was held two weeks later in the sailors' boardinghouse[73] on C Street between Front and First Streets belonging to Mr. James Turk. The meeting was attended by a number of sailors, and Chaplain Stubbs brought along some ladies from the Methodist Episcopal Church who sang a set of lovely duets to the accompaniment of a folding pump organ. One can only imagine the figure of a hung over Turk lurking in the shadows. It was the only time on record that the bethel was held there.

By 1883, the society had raised enough to construct a three-storied, "fine, substantial brick" mariner's home and bethel covering a quarter of a block, 100 feet by 100 feet, on the northwest corner of Third and D Streets—a building that still stands to this day. Apart from the lot and furniture, it cost $13,000. It had a "capacious coffee room" where inexpensive meals could be purchased, a reading room, a library and sleeping rooms "furnished with good spring beds, neat bed-clothes and other appliances equal to those found in moderate priced hotels and in much better order and style."[74]

From the very beginning, the bethel ran into problems with the Portland crimps. False charges of shanghaiing and secreting deserting sailors were brought against the management. Ship's crews and captains were threatened and warned against using the establishment. It was with a heavy heart that years later, in 1899, British Vice Consul Laidlaw, one of the biggest supporters of the project, added in his official report to his superior, the Marquis of Salisbury, words to the effect that the crimps had won this battle. Laidlaw wrote, "Some time ago the Mariners' Home, a respectable institution owned and operated by the Seamen's Friend Society, had to be closed because the British shipmasters, as a general rule, preferred to patronize notorious crimps, and would not take seamen from the home."[75]

Laidlaw included in his report a complete list of the Oregon statutes forbidding every aspect of the sailors' boardinghouse trade to provide proof that it was lax law enforcement and not lax laws that were at the heart of the problem.

The American Seamen's Friend Society man in Astoria, Chaplain J. McCormac, had an even worse time of it. In asking for contributions, he made this despairing statement:

> Ours indeed is "darkness that may be felt." The greatest difficulty we have to encounter in grappling with this darkness is the boarding house master system. It is the grand aim of boarding house masters and runners to keep their victims half-drunk all the time, so that they can manage them, and, of course, in that condition we can do little or nothing for them. Volumes might be written upon the wrongs perpetrated upon poor sailors by these bad men in this place.[76]

CHAPTER 5

THE FERRIES AND BRIDGES
OF THE EARLY DAYS

FERRIES ACROSS THE WILLAMETTE

The first ferry of any importance was powered by a mule on a treadmill attached to a paddle wheel. This sturdy craft, nicknamed *Black Maria* on account of its color, was guided across the Willamette by means of a submerged cable. Built by pioneer James B. Stevens, it was a great improvement over an earlier affair that floated on canoe pontoons. In 1860, Stevens sold the ferry (and presumably the mule as well) to a serious capitalist of the monopolist school named John Knott. These were the humble beginnings of the mighty Stark Street Ferry that ran without the annoyance of competition for many years. The *Black Maria* gave way to a succession of large and accommodating steam-powered vessels, while John Knott and his sons kept any would-be competitors tied up with lawsuits. The Stark Street Ferry ran until midnight, after which a rowboat was available in case of emergencies

In 1880, W.S. Chapman won a court battle with the Knott brothers allowing for the Jefferson Street Ferry. This ferry opened using the powerful steam ferry *Veto* on a route from Jefferson Street in the west to U Street (now Hawthorne) in East Portland.[77] The Jefferson Street Ferry ran until the Morrison Bridge was completed seven years later. Both the Knott brothers and Chapman, along with many of the owners of shipping companies, tried to keep bridges from being built. Even swing bridges were considered an

Stark Street Ferry, circa 1888. *West Shore.*

impediment to business because of the amount of time it took to open and close the affairs. The Jefferson Street Ferry ran back and forth from early morning until 9:00 p.m.

When Ben Holiday brought the Oregon and California Railroad (O&C) into Albina in 1870, the railroad established a ferry landing below the foot of Ninth Street. This ferry connected the O&C terminal at the foot of Oregon Street in Albina with Portland railroad and steamboat terminals on the west side. Another ferry operating in the north of town was the Albina Ferry. The landing on the Portland side was next to Mersey dock at the foot of Seventh Street. On the Albina side, the landing was at the foot of Knight Street (later called Albina Avenue). The Albina Ferry went into operation on October 2, 1875, and continued to run until after World War I. The Albina Ferry originally ran from a landing near the OR&N Co. boatyard (usually called the "boneyard") during the week and F Street on Sundays before moving to its Seventh Street location a few years later. The railroad ferry ran until 6:00 p.m, unless there was a late train.

There was also an OR&N Co. railroad ferry landing at the end of a trestle that entered the river at about the foot of Fourth Street, north of the Steel Bridge. The ferry carried railroad cars across the Willamette River to a trestle that inclined into the water just north of Victoria Dock, at about the foot of A Street in Albina. This was a ferry for transporting railroad cars only and was never used for passengers.

Before a Columbia River bridge, the Northern Pacific railway took railroad cars and passengers across the Columbia by the giant railroad ferry *Tacoma*. The Oregon landing was named Hunters, where the town of Goble is today, and the Washington terminal was at Kalama.

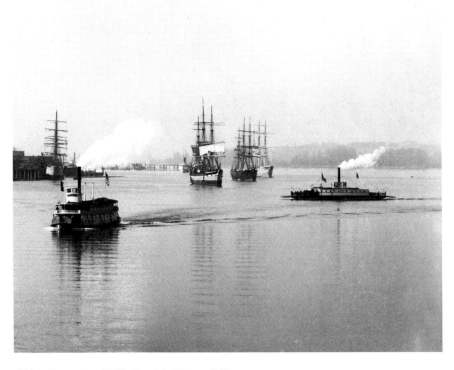

Albina Ferry, circa 1890. *Copyright Thomas Robinson.*

In 1893, after Albina, East Portland and Portland were joined, the city purchased the Albina Ferry as a free ferry for foot passengers. The Albina Ferry became such a popular commuter route that another ferry was added in 1903. The Albina Ferry landings were about a half-mile apart on the west side—the upper landing at the foot of Ninth Street and the lower landing at the foot of Seventeenth Street. Both ferries met at the foot of Knight Street (later named Albina Avenue) in Albina, just south of Montgomery Dock No. 2. The ferry shut down for the day in early evenings. For emergencies, a rowboat would be hired to cross the river.

Besides the Portland ferries, two other ferries operated in the area: the St. Johns Ferry (which opened in 1907) connecting St. Johns with Linnton Road (until the Saint Johns bridge was completed in 1927), and the Sellwood Ferry (which opened in 1903) connecting Spokane Street in Sellwood with the White House Road, near the location of what is now the Sellwood Bridge.

THE MORRISON BRIDGE, THE BRIDGE OF DREAMS

The promised bridge across the Willamette became a running joke in early Portland—one that lasted for many years. Old-timers would tell of a time during the great land speculations of the 1860s when every other house in Portland was a real estate office. In those days, a bridge crossing the Willamette seemed inevitable; therefore, speculators were buying land in East Portland and then turning around and selling lots for inflated prices. By the July Fourth celebrations of 1870, the river was still without a bridge. A self-styled "poet laborer" named Stephen Maybell climbed the steps to the podium in the midst of the festival grounds and recited, to the delighted audience, a poem that he claimed was divinely inspired. The poem told the story of a young man who was waiting for the bridge to be built.

> *Behind the pines had sunk the sun,*
> *And darkness hung o'er Oregon,*
> *When on the banks of Willamette*
> *A youth was seen to set and set;*

> *And set and sing unto the moon*
> *A wild, yet sweet, pathetic tune—*
> *They are going to build, I feel it yet,*
> *A bridge across the Willamette.*

By the end of several long and amusing verses, it was no longer a man who was staring at the river and chanting the refrain, but a ghostly skeleton.

> *Which turned its hideous, fleshless head,*
> *And grinned most horribly and said.*
> *They are going to build, I feel it yet,*
> *A bridge across the Willamette.*[78]

This was humorous in 1870, but the bridge did not arrive until April 1887, making the refrain into a sarcastic summarization of Portland politics. The ferry monopolies managed to find ways to keep the bridge-building efforts tied up in court until the situation became ludicrous. Finally, the Morrison Bridge, a swing bridge to allow for river traffic, opened in 1887. The charge for pedestrians crossing the bridge was five cents, although books of tickets, called "footman tickets," could be purchased at a cost of twenty-five cents for

The first Willamette River Bridge (Morrison Street) shortly after completion in 1887. The tollbooth is prominent in the foreground. *Copyright Thomas Robinson.*

eight tickets. This timber span bridge would only last eighteen years before it was replaced by one using steel girders. The new bridge was constructed with more substantial materials and served the city until 1958 when it was replaced by the present-day automobile-friendly drawbridge.

THE STEEL BRIDGE

In 1888, the OR&N Co. railroad built a railroad bridge over the Willamette just south of the Albina Ferry. It was a single-span swing bridge that was replaced in 1912 (at a point three blocks farther south) by the drawbridge we see today.

The first bridge consisted of one swing (dray) span and one closed span. The swing span at the western end had a length of 340 feet, giving it a clear opening on either side of the pivot pier of 150 feet for the passage of vessels. The closed span was 320 feet in length on the east end. The lower deck was a mere 2 feet above the river at flood level; it was used for railroad trains running on a single track. The upper deck was a toll bridge for wheeled vehicles, streetcars and pedestrians.

The present (new) Steel Bridge is a lift bridge with telescoping lift spans that allow the lower deck to be raised independent of the upper deck. This was a first in the world of engineering. The lower deck has dual railroad tracks for exclusive use of the railroad. The upper deck allows for the passage of streetcars, vehicles and pedestrians. In 1898, the Union Pacific purchased a majority stake in the OR&N Co. and later absorbed the company under the Union Pacific name. This bridge is still owned by the Union Pacific railroad and is open for public use by agreement with Multnomah County.

THE MADISON/HAWTHORNE BRIDGE

A bridge to bring the Hawthorne line street railway into the city was proposed to the city council by the Mount Tabor Street Railway Company in December 1889. Construction began the following spring, and the bridge

Vancouver Ferry with the railroad bridge in the background, circa 1908. *Copyright Thomas Robinson.*

was opened to the public in April 1891 as a toll bridge for wagons, bicycles and pedestrians. Before the bridge opened, an *Oregonian* reporter noted, "At present the children of the neighborhood find it an excellent place for roller skating and monopolize the approach."

These new bridges created a whirl of activity on the east side of the river as land was snapped up by real estate dealers and speculators. Street railway companies cooperated with developers to build streetcar lines to areas where there was nothing but forest or meadowland. The streetcar lines were used by building contractors to bring supplies to these outlying developments. Even before houses were built, the neighborhoods were provided with a means of transportation to jobs, shopping and entertainment in the city.

In June 1902, sparks from casting being done at the Phoenix Iron Works beside the east end of the Madison Street Bridge started a blaze that soon swept the east side, fed by oil from the Standard Oil Company plant. The

bridge, though damaged, was repaired and able to be used until it was replaced by the present-day Hawthorne Bridge in 1912. This historic bridge is one of the most recognizable landmarks in the city.

FREE BRIDGES MOVEMENT

In 1891, C.H. Meussdorffer presented the Oregon legislature with House Bill 38 to provide free bridges in Portland. The legislature authorized a free bridges committee for this purpose. The bill allowed for the planning and constructing of bridges and the purchasing of existing bridges and ferries but created a legal brouhaha that went on for years. When the subject of buying the Morrison Bridge was looked into, it was discovered that its foundations were dangerous. The free bridges committee devised a plan that included building a bridge at Burnside Street and purchasing the newly built Madison Street Bridge, belonging to the Mount Tabor Street Railway Company. The U.S. War Department's approval was necessary for building bridges across navigable waterways, and the list of bridges that they approved during this time included a bridge at Knight Street in Albina crossing to Quimby Street on the west side. The committee decided it would be more useful to the community to spend the money purchasing the Albina Ferry and operating it as a free ferry. By this time in the development of the city, the majority of workers lived on the east side of the river, where large developments called "additions" had been built. The free bridges movement met with a great deal of opposition from "west siders," but it was politically expedient for elected officials to support the idea. The Madison Street Bridge was purchased by the city and made a free bridge, just seven months after it opened. Presumably the children with roller skates were delighted that they could skate across the entire bridge without spending any of their candy money on tolls.

BURNSIDE BRIDGE

In order to build the Burnside Bridge, the city was forced to bring a condemnatory lawsuit against two of Portland's old pioneer widows, Mary H. Couch and Maria L. Flanders—old Portlanders who typically opposed bridges in general and, more particularly, bridges built on their property. This too was a bridge with a swing span. On its first trial swing, it was christened by the breaking of champagne bottles on the girders, although Mr. Meussdorffer declared that it nearly broke his heart to see extra dry Monopole treated in this manner. The bridge opened to the public amid much fanfare on July 4, 1894. This bridge would see thirty years of service before being replaced by the present-day steel and concrete drawbridge.

BROADWAY BRIDGE

Another well-known Portland landmark, the Broadway Bridge, is a steel girder (bascule) drawbridge designed by civil engineer Ralph Modjeski. When the bridge opened in 1913, it was the largest of its type in the world. The bridge is painted the color of dried blood. Its design is such that little can be done to ruin it, short of demolition. The distinctive red lantern lamps disappeared for several decades, replaced by ghastly fluorescents, but the city illumination engineers saw the error of their ways and restored the bridge to its original level of utilitarian beauty.

THE WILLAMETTE RIVER BRIDGE

Many Portlanders draw a blank when asked about the bridge originally named the Willamette River Bridge (known today as the Burlington Northern Railroad Bridge or Wilbridge). This is a railroad bridge operated by the Burlington Northern railway. Tucked into the industrial area between the Saint Johns Bridge and Swan Island, it is the least visible of all the bridges.

When it was opened in 1908, it was the longest draw-span (swinging) bridge in the world.[79]

THE INTERSTATE BRIDGE

The Interstate Bridge opened in 1917, just a few weeks before the United States entered World War I. This lift span bridge, spanning the Columbia River to join Portland with Vancouver, Washington, was long anticipated and seriously debated for decades before it was finally built. Since the Oregon approach to the bridge was located in a sparsely populated, marshy area, a great deal of new road work was necessary to connect the bridge with the boulevards of Portland—especially a long viaduct at the north end of Union Avenue. The day the bridge opened, the Vancouver Ferry ceased to run. It had been in business since 1876, and closing day was a sad day for Captain Frank Stevens, his chief engineer A. Munger, and many of the crew members who had worked on the company's several ferries since its beginnings.

In 1958, to accommodate heavy use and to prepare for the new Interstate 5 freeway, a nearly identical bridge was built next to the original—one bridge for northbound traffic, the other for southbound traffic. These bridges are still in use by the freeway, although they are hardly adequate for the heavy traffic of a twenty-first-century interstate superhighway.

LATER BRIDGES

The focus of this book is the period before World War I, a time when the Willamette River was the main highway of the region, and river traffic was heavy. As train travel increased, travel by steamboat became a thing of the past. From the late nineteenth century up to 1920, the good roads movement helped to create a system of highways that made automobile travel popular. Over the years, more bridges were built in Portland, many to accommodate motorized traffic only. The following is a brief mention of bridges built (or rebuilt) in the years after World War I.

- The Sellwood Bridge, opened in 1925, is a high bridge without the need of a lift span.

- The Burnside Bridge (No. 2), completed in 1926, is a drawbridge replacing the swing span bridge built in 1894.

- The Ross Island Bridge, completed in 1926, is a high bridge.

- The Saint Johns Bridge, completed in 1931, is a high bridge.

- The Morrison Bridge (No. 3), completed in 1956, is a drawbridge replacing the swing span bridge built in 1905.

- The Marquam Bridge, completed in 1968, is a high freeway bridge.

- The Fremont Bridge, completed in 1973, is a high freeway bridge.

- The Burlington Northern Railroad Bridge (No. 2), completed in 1989, is a lift span replacing the old swing span.

- The Portland-Milwaukie Light Rail Bridge (also called the "Caruthers Bridge") is a bridge to accommodate light rail, pedestrians and bicycles from downtown to the east side of the Willamette. This bridge is under construction at the time of this writing. The 77.5-foot clearance of this bridge allows for the kinds of river traffic (mostly pleasure craft and tugboats with barges) using the river upstream from downtown Portland.

TUNNELS BENEATH THE WILLAMETTE

In 1906, when it became painfully obvious that the Madison Street Bridge was on its last legs, Mayor Harry Lane proposed that the most practical solution to the problem would be to tunnel beneath the river. This way, river traffic would not be congested by the slow opening of a drawbridge. "Bury the bridges as they fall, and build subways instead," declared the mayor.

This may seem a bit unusual to present-day Portlanders, but if you count the number of steamboats traveling to and from all points of the compass in those days and then consider the length of time it took the engines of the bridge to swing the spans open and closed, the idea seems quite valid.

The "new" Steel Bridge, circa 1912, being crossed by a locomotive on the lower deck and trolleys on the upper. *Copyright Thomas Robinson.*

When asked what should be done with the railroad bridges, Harry replied: "Make them dive also."

Mayor Harry seems to have been in the minority on this issue though, and voters swung in favor of a draw span instead of a tunnel, or Portland would have been left without its iconic Hawthorne Bridge.

A few years later, in 1910, the free bridges movement was at its height. Some of Portland's biggest movers and shakers found themselves on opposite shores of a heated argument over what to do about the Broadway Bridge. There was a lot of public support for the bridge, led by Judge M.G. Munly. The Port of Portland Commission and C.K. Henry, a powerful east side real estate man and politician, strongly opposed the idea. River congestion was again the main issue, and once again the subject of a tunnel came up. This time C.K. Henry wrote a lengthy article, illustrated with images of the Detroit River Tunnel (a project Henry saw as being

nearly identical) and paid for its insertion in the *Oregonian*. The article also detailed a larger project in Sydney and Chicago's La Salle Street Tubes. Portlanders on both sides of the river were not swayed, and the lovely Broadway Bridge was built. The idea of "Bridgetown" must have been as charming then as it is today.

CHAPTER 6

THE GREAT GRAIN FLEET

From the earliest years of exporting wheat from the wharves of Portland, the vessels carrying the wheat away were called either the "grain fleet" or, more endearingly, "our grain fleet," even though the ships of the fleet were nearly always British. At the end of the shipping season in 1874, the number of vessels in the grain fleet was fifty, a jump from twenty-nine the previous year.[80] By 1888, the number had risen to seventy-three, with a combined tonnage of 93,320. By the turn of the century, Portland was deeply appreciative of the grain fleet, so much so that in November 1900, the *Sunday Oregonian* devoted its entire front page as a sort of romantic adulation of the fleet, starting off with the following poem and covered with images of the lovely, tall ships at the wharves or anchored in the harbor.

> *Their tall masts seem to touch the clouds;*
> *The gray mist clings about their shrouds;*
> *The "lady's head" upon the prows*
> *Looks seaward, while with level brows.*
> *They are so stately and so still,*
> *Yet they have felt the sudden thrill*
> *Of tempests, tropic-born, and fast*
> *Fled, shrieking from the furious blast*
> *Or when the Summer moon was young,*
> *And like a silver sickle hung*

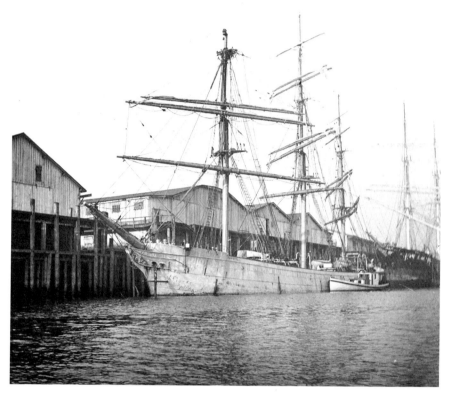

The German schooner *Christel* (formerly the British ship *Old Kensington*) at a west side wharf, circa 1902. *Copyright Thomas Robinson.*

Against the tender, darkening sky,
They felt the twilight breezes sigh,
Until their idle sails blew white,
Soft, ghostly clouds across the night.
Ah, they are clothed in mystery,
Wrapped in the romance of the sea.[81]

In the season from June 1899 to June 1900, the grain fleet numbered ninety-nine vessels. Many of these vessels were considerably larger than the grain ships of the early days, some having a draft of thirty feet. From Portland to the sea during this period, a draft of twenty-five feet was usually practicable from March until July. During the dry months of August to

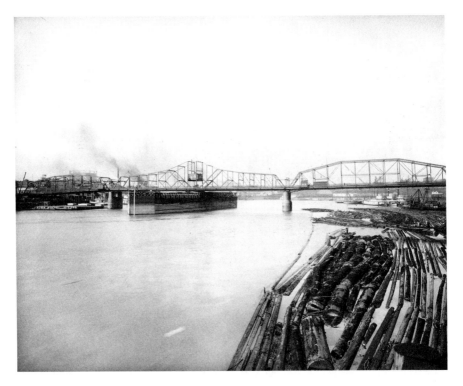

The first Burnside Bridge with the cranes of Star Sand Company visible in front and the gas works storage tower seen behind, circa 1895. *Copyright Thomas Robinson.*

October, it dropped to twenty feet or less, and from November to February, twenty-three feet was the norm. Even after decades of dredging, larger vessels still often found it necessary to lighter part of their load to Astoria at the Columbia River's mouth. The combined cargo of the 1900 grain fleet—counting lightered cargo, of course—allowed Portland to surpass even the Puget Sound in exports. That year, only four ports in North America exceeded Portland in grain exports.

By this time, the vessels of the grain fleet were no longer exclusively British; there was also a handful of French, German and even American vessels. In 1900, when the merits of the grain fleet were being examined, the vessel that was given the most attention was the magnificent four-masted, 305-foot-long French bark *Europe*. This steel-hulled ship was beautiful to look at sitting at Montgomery Dock No. 2 across the Willamette in Albina.

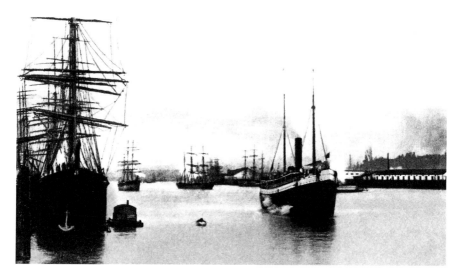

Portland harbor toward Albina showing vessels dockside, and at anchor awaiting a berth, circa 1900. *Postcard, author's collection.*

A more beautiful vessel is not often seen in this or any other port. She is but one among the splendid ships that constitute the grain fleet, and when she sails from these shores southward, on her way around the American Continent, she will carry a cargo of 3,000 tons[82] of golden grain that ripened beneath the genial sun of Eastern Oregon and Washington.[83]

The report moved from poetical toward philosophical, disagreeing with "Ruskin's[84] notion that commerce is without aesthetic features." The movement of grain from the fields of the Pacific Northwest to all parts of the earth, and the grain fleet that carried the cargo was itself seen as a thing of sublime beauty.

Its commercial utility in no way detracts from the romance and the poetry that are the inalienable characteristics of the grain fleet of the Willamette. Any ship that sails the high seas embodies this romance, this poetry. In every mast and spar and shivering timber she is thrilled with the hidden meaning of the deep.[85]

It is good to know that these vessels were loved for their beauty and value, and that as streetcars crossed the bridges of Portland, passengers would look

out at the forest of masts rising from the wharves along the Willamette and dream of the romance of the sea and ponder the "hidden meaning of the deep," rather than pondering the wickedness and corruption of the sailors' boardinghouse masters and avaricious captains. There was much to be said about this "romance." A sailor's life was one that was loved by many men, in spite of its many hardships.

By 1901, Portland had beaten both the combined Puget Sound ports of Seattle and Tacoma and San Francisco, making it the largest grain export port on the Pacific coast.

THE MOVEMENT OF CEREALS TO THE SEABOARD

In 1848, a machine was set in motion by Asa Lovejoy when he built a wharf and a warehouse for grain and then lay a plank road over a low pass in the Tualatin hills to the wheat fields of North Plains. The men laboring to scrape out a wagon path and then lay down the planks probably never dreamed that this sort of labor would continue to be built up, in ever increasing volume, until a great metropolis was established. The labor of transporting the natural resources of this rich land to merchants around the world was set in motion in those early days. Had hearts grown weary at any point along the way—had Mr. Corbett gone fly fishing, instead of lobbying in Washington, D.C., for better shipping channels; had Henry Villard fallen in love with Tacoma instead of Portland and made that his Pacific terminus—things would have turned out differently.

A great grain pipe was put in place during the last two decades of the century that brought wheat to the docks and flouring mills of Portland via rail and barge from all parts of the Columbia River basin. Large lumber mills were established along the river to receive log rafts cut from ancient forests. Given that the mills were here, it is only natural that shipbuilding companies would establish themselves along the riverbanks. Even by the turn of the century, when steel-hulled vessels were becoming quite common, many shipowners still preferred the buoyancy and economy to be gained by having a well-crafted wooden-hull ship. This would hold true until after World War I, when ocean shipping became the provenance of steel giants.

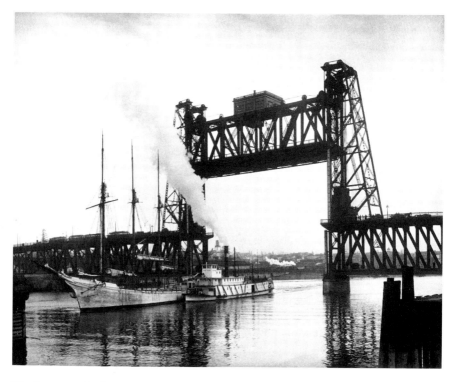

The four-masted schooner *J.H. Lussman* being towed from the grain docks to Astoria by the Union Pacific steamer *Ocklahama*, circa 1912. *Copyright Thomas Robinson.*

DRY LAND WHEAT FARMING

The early pioneers were mostly farmers, men and women lured by tales of the lush Willamette valley. These farmlands were rapidly allotted on a first-come basis to the members of the first early waves of wagon trains. Subsequent settlers had to either buy land at inflated prices or make use of what remained.

By the 1880s, when the only land left was in the dry eastern regions, farmers planted large areas of eastern Oregon and Washington with varieties of wheat that would grow without much water. The grain from these regions greatly increased the exports from the wharves of Portland.

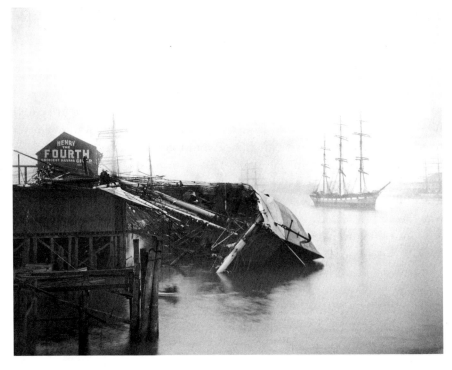

The French bark *Asie* came to load grain but capsized while discharging ballast at Davidge's wharf (north of Mersey Dock), on New Years Eve 1901. *Copyright Thomas Robinson.*

All along the Columbia River and its tributaries, reaching up into Idaho, grain elevators, wharves and warehouses were erected to handle the yearly harvest. By the year 1887, the wheat shipped from the eastern region had increased to more than twice that of the Willamette valley. Wagons laden high with sacks were pulled by horses over the Tualatin Mountains to the Portland waterfront. Steamboats towed barges through the government locks at Oregon City, on the Willamette, or the Cascade Locks on the Columbia, and railcars from all compass points would meet in Portland to be distributed to the world.

THE PACIFIC COAST GRAIN ELEVATOR SYSTEM

In the fall of 1889, the Oregon Railway and Navigation Company completed its system of thirty inland grain elevators along a line connected to the new Pacific Coast Elevator in Albina. This massive structure could hold one million bushels of wheat. The facility for unloading railcars filled with bulk grain was capable of handling eight railcars at a time and thirty-two railcars in one hour. This is an impressive figure even by today's standards. The elevator towered over the Albina docks, being much taller and larger than anything else along the river. The structure was formed of wood, so greater care than usual was taken to limit the amount of explosive grain dust in the air. The elevator received grain in bulk but shipped it in sacks, having a sacking system capable of one hundred sacks per minute. A "dustless cleaning system" removed dust from the bulk product by vacuum and dumped it down a pipe into the Willamette River.[86] Every floor had water pipes and a fire extinguishing system with water barrels every few feet. Although it was a grain elevator, it did not load vessels with bulk grain but rather, it had equipment for sacking grain prior to loading it aboard ships.

Sacks of grain being weighed for export in a Portland grain warehouse. *Courtesy Agricultural Marketing Service.*

This was the first of the great grain exporting elevators in Portland, with the OR&N Co. changing the way the grain trade operated. The "grain pipe" system of companies owning inland elevators up the Columbia basin with an export elevator in Portland (or the lower Columbia River) is still in use today. Even though this elevator dominated the grain business and the skyline in Portland for a number of years, few people today have ever heard of its existence. In late September 1894, the massive building went up in flames, taking along with it a half mile of Albina wharves, including the nearby coal bunkers (coal docks for supplying ships). Also destroyed in those spectacular flames were sixty railcars, the steamship *Willamette Chief* (once the pride and joy of the OSN Co.) and many tons of wheat. All the precautions had been for naught. The fire had started by spontaneous combustion in the nearby coal bunkers and had spread to the elevator, causing the wooden structure to burn from the outside and making the firefighting equipment on the inside useless. For a time, it was feared that the wharves across the river would be ignited, but fortunately the winds were not that strong. A year or so later, when the OR&N Co. rebuilt, they built a massive one-thousand-square-foot warehouse. It wasn't quite as impressive as the previous structure, but this time it was linked to a system of over fifty inland elevators.

THE FLOURING MILLS

Even before Will Overton laid claim to the clearing where Portland stands, flour was being exported from the region. The first gristmill in Oregon was built by the Hudson's Bay Company near Champoeg, with a later one constructed at Oregon City. Wheat and flour were both as good as gold in the frontier, better in some obvious ways, especially when gold was in abundance and food was in short supply. It can be noted that when the first of the Oregonians with "gold fever" left on the schooner *Honolulu* for the gold fields of California, they took with them barrels of wheat and flour. Within a short while after the arrival of the Willamette Valley settlers, small mills had been erected throughout the valley.

The first large export mill in Portland was the Portland Flouring Mill. It was built in 1883 on the east side of the river in Albina, just north of what was then the Northern Pacific rail yard, and is today the Union Pacific

Portland's first bulk grain elevator was built by the California and Oregon Grain and Elevator Company in 1913. The cement tanks still exist, though the warehouse burned in 1960. *Pacific Monthly.*

yard. The company also owned a large mill in Tacoma, making it the largest milling company on the Pacific coast. Company president T.B. Wilcox was an early entrepreneur whose mansion still stands on the Portland Heights. The mill itself was built to last. It would go through a total of six owners before finally being demolished in 1968 to make room for port development on Swan Island. When the mill was first built, it commanded a great location in what was the gate of the city. Every vessel entering the harbor passed close by the wharves. This was the east channel of Swan Island, the west side being impassibly shallow. People who know the area might be surprised to learn this, since today Swan Island is no longer an island, and the channel was long ago opened on the west of the island. The east side is now connected to the rest of north Portland along what is called "Mock's Bottom."

In 1910, Crown Mills built a flouring mill on the west bank near Quimby Street. This structure can be seen in many harbor photographs taken after that date. The building is still standing, although it has long ceased to be a flour mill.

GLOBE DOCK

In 1913, Globe Grain and Milling Company built the first export grain elevator in Portland for the purpose of shipping grain in bulk. The company had its own fleet of ships built to carry bulk grain cargos. This grain elevator, just north of the Steel Bridge, is still being used today. This dock originally had a five-hundred-square-foot warehouse for storing sacked grain, a method of shipment that would continue into the 1960s.

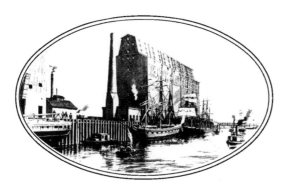

Pacific Coast Grain Elevator

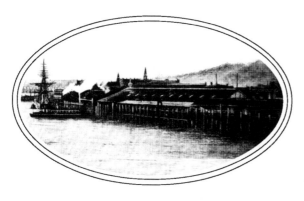

O.R.&N. Ash Street Dock

Facsimile by author from images in *Wealth and Resources of Oregon and Washington, the Pacific Northwest* (Portland: Passenger Department of the Union Pacific Railway, 1889).

THE WEST SIDE WHARVES AND WHITECHAPEL

Whenever Lloyd's of London marine surveyor Captain George Pope looked up from the deck of one of the vessels he was surveying to cast his eyes upon the downtown wharves, it made his stomach churn. The photographs we see today display a sort of picturesque chaos, but to the eyes of someone whose profession was to ensure straight lines and near perfection in vessels, it was a mockery of good taste. In one of his heated letters to the editor on the subject, he spared no words:

> Our waterfront is the most wretched portion of our city. A quarter of a century ago, when Portland was a mere village, our wharves were built in a higgledy-piggledy manner. Each property owner laid out a wharf line for himself, and trusted to chance to have it rectified. The result was that we have the most unsightly wharf line to be found anywhere. I mention this merely to draw attention to the fact that by the construction of a seawall the beauty of our already lovely city would be greatly enhanced by remedying one of the greatest defects.[87]

By the end of the nineteenth century, the "higgledy-piggledy" wharves were the low-rent district of downtown, as they were within smelling distance of the sickening effluvia rising from the murky Willamette. The lower levels of the wharves were regularly underwater during the high water season, rendering them mostly useless. The structures had become warehouses for the most part; the western-style false fronts facing the river were painted

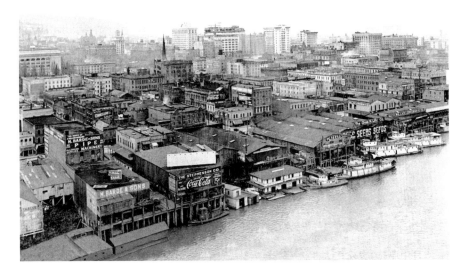

The White Collar Line's Ash Street Dock with daily steamboats for The Dalles and Astoria. *Postcard, author's collection.*

with advertisements in various levels of peeling and decay. The log piles driven in the early days had started to rot and lean in places, and the entire lower panorama of the city had taken on a distempered look, the antique patina of decline. Deterioration caused by time and weather was a thing of beauty compared to the social decay in the underworld that thrived along the waterfront. This territory reached from the south marshes, across the verge of downtown, past the coal gas plant in the north end and up to the North Pacific Lumber Mill by Guild's Lake. The grain warehouses from Alber's Dock to Mersey Dock presented a more businesslike appearance, as did the Albina grain warehouses across the river, but the burned-out ruin of Weidler's Mill, the ballast docks, and the O.R&N. boneyard were an industrial wasteland.

The north end, known on maps as "Couch's Addition" after Captain John Couch, was in the 1860s the part of town where the grand homes were built. Although the residences were grand and constructed in the Victorian fashion of opulent extravagance, the close proximity of this area to the waterfront ensured that the neighborhood would attract other uses than houses with yards taking up an entire city block. Some development of businesses and

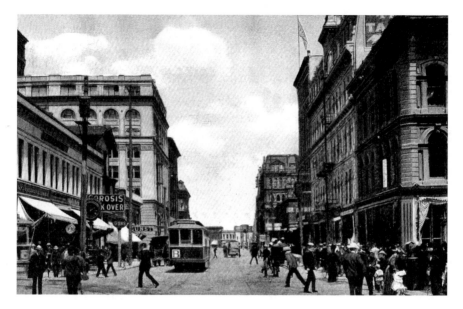

Third Street in the Whitechapel district, where night and day were completely different worlds. *Postcard, author's collection.*

"low resorts" around the year 1883 caused a mass exodus by the wealthy families who suddenly, "almost magically," moved northwest to the area around what is called Nob Hill. The *Portland City Directory* of 1884 mentions the exodus in this passage:

> *A most remarkable change in the present volume, as compared to its predecessors, is the removal of many families whose names are familiar in the history of Portland from the localities which but a year or two ago were reckoned the most aristocratic and desirable residences in Portland. North Third and Fourth streets, which were the sites of our most elegant residences have been abandoned to business, and the denizens of that portion of the city have as completely changed in character as their surroundings. The blackberry pasture and forlorn waste of stumps in the western precincts have been reclaimed and improved almost magically, and for a half mile square in the former suburbs of the city at the north end the dwellings erected during 1883 may be called almost palatial.*

Having recently risen from being a log plank village inhabited by the rustic types found in serialized fiction, Portlanders were self-conscious enough about their city to develop a "state of denial" about the city's dark side, thinking only of "beautiful Portland," with its lovely church spires, somber business section and grand houses nestled among the fir stands and cedars of the western slopes. The waterfront was a place most Portlanders passed through but did not linger.

At night the wharves were the haunt of homeless youths and hobos. Daylight brought a different sort of person to the bustling wholesale houses, commission merchants offices and small industries along Front Street, but with nightfall the saloons, blind pigs, *bagnios*, gambling dens and bawdy houses came to life with the colored lights and gaudy music that made such places attractive to the mostly transient men who inhabited the area.

Before laws against prostitution began to be enforced in 1903, the north end contained a surprising number of "low resorts" of various sizes, from small, private *bagnios* operated by a single woman and her *macquereaux*,[88] to "hotels" with floors sectioned into eight-by-ten-foot "cribs." Among these was the famous and long-lived Erickson's Workingman's Club and Saloon, which took up half of a city block. Except for prostitutes, this section of the city was almost exclusively composed of single men living in cheap rooms. Some of the better-known sailors' boardinghouses were located there, as was the Sailor's Home, belonging to the Portland Seamen's Friend Society, and the Salvation Army rescue mission.

Around 1897, businessman and architect N.J. Blagen built a four-story brick building on First Street and Couch to lease to sailmaker W.C. Noon for use as a factory. When the sailmaking began, using up to eighty-three seamstresses, it so happened that the prostitution in the area was a great disruption to his business. The activities could be seen out the windows of the building, and his employees were harassed and humiliated daily on their way to and from work. Blagen sought an injunction against the lessee of the property next door where makeshift "cribs" for prostitutes were erected. This injunction stopped the business temporarily, but the Oregon Supreme Court ruled against it in an interesting document that itemizes the businesses of the area in a way a city directory or newspaper would be hesitant to do. Here is a small example:

> *Long prior to January 1, 1897, there was situated directly across the street from said property of N.J. Blagen a house of prostitution kept by*

one "Liverpool Liz," and on the corner of First and C streets, diagonally across the street, there was what was known as the "Bella Union Theater," a mixed saloon, where women resorted and sold liquors; that next to the building occupied by Liverpool Liz there stood a sailor boarding house, kept by Jim Turk; this part of town is known as part of the Whitechapel district. That at the time of bringing this suit there were, and still are, situated within two blocks of said property of N.J. Blagen fifteen saloons, and over twenty-eight houses of prostitution, called "cribs," and that said cribs or houses of prostitution and saloons have been standing on said property for several years prior to January 1, 1887.[89]

THE ORIGINS OF THE NAME "WHITECHAPEL"

Since Nob Hill, where the wealthy classes had retreated, was also in the north of town, the Right Reverend R. Wistar Morris, the Episcopalian bishop of Oregon, led a movement resisting use of the term "north end" in reference to the district of red lights and vice. Bishop Morris declared that it cast a dark cloud on the whole area.[90] Newspapers began to half-jokingly use other terms. Two of these, Whitechapel and Bad Lands, had staying power. Use of this term "Whitechapel" predated the murders committed by the "Whitechapel Fiend" of London, Jack the Ripper, whose vicious murders of prostitutes fascinated newspaper readers around the world from 1888 until 1891. It is most likely adopted from the "Whitechapel" of Charles Dickens's London, Dickens being the world's best-selling author at the time. The north end was indeed Dickensian in every shape and form and was inhabited by the most Dickensian of characters, such as Mr. Turk, Nancy Boggs, Crawfish Charlie, Paddy "the Canary" Lynch or even Bunco Kelley, to name a few.

The Reverend J.E. Snyder was a Baptist minister who considered himself the "Whitechapel Apostle" and who spent many years working with the social outcasts of the area. In a sermon reprinted in the *Oregonian* in 1901, he circumscribed the heart of the area as being composed of the fourteen blocks bounded by Pine Street to the south, Flanders to the north, from Fourth Street to the west and bounded by the wharves and river to the east. He told how when he came to Portland he had looked on the bright side of things, saying, "When I passed through a portion of Whitechapel, seated in

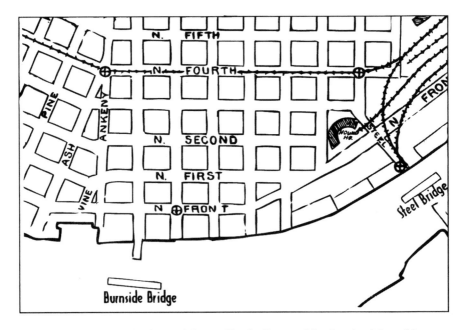

Portland's Whitechapel district, as delineated by the Reverend Snyder, chaplain to "the fallen." *Derived from a 1901 Sanborn map.*

a trolley-car, I shut my eyes—in those early days. One day I took my wife there to see social conditions, and she fainted. I called a carriage and took her home."

The Reverend J.E. Snyder and countless other self-sacrificing souls spent their days among the publicans, the prostitutes and the other sinners of Whitechapel. From a time starting a few years after the exodus of high society in 1883, the name Whitechapel was used frequently in the daily news. After the brothels closed in 1908, the name quickly disappeared so thoroughly from news reports about the north end that it is almost as though it were by mutual agreement. The name has faded and much of the open vice has gone away, but the spirit of the place still can be found without a great deal of difficulty—and this after a period of well over one hundred years.

In 1884, in the beginning years of the corruption and vice in the Whitechapel district, both the *Sunday Welcome* newspaper and the *Daily Astorian* took the law enforcement system to task and published an accounting of police graft in Portland that named names and cited figures. The area was under the care of

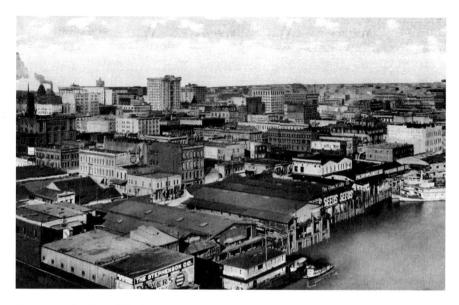

The "higgledy-piggledy" wharves that gave Captain George Pope a stomachache. *Postcard, author's collection.*

"special policemen" who were paid a mere one dollar per month by the city. The rest of their salaries, which were a fortune by the standards of the day, were paid as a sort of protection racket run under the patronage of the city for the enrichment of the men in power. Even though the *Daily Astorian* rarely had a good word for Portland and the *Sunday Welcome* loved to rake the muck, the following list of accounts was not publicly challenged, and therefore I assume that it is accurate. From the *Sunday Welcome*:

> *Fat Billets*
> *Amounts per month paid to J.F. Watson, whose beat extends from Front to Fourth streets and from Washington to Morrison. Seventeen Chinese tan games, with 62 gambling tables, $4 per week for each house, $272; 14 lottery houses at $2 per week, 129; 126 white business houses at $1.50 each, $188; 8 houses of prostitution at $5 each, $40; 35 Chinese business houses at $1.50 each, $82; 4 faro games $64; from the city of Portland, $1; total per month $766.*
> *Special Officer A.B. Brannan, whose beat is from east of Fifth, north of Oak and south of A streets, received per month: Seven saloons at $2 per*

month each, $14; 68 white business houses at $1 each, $68; four banks at $2 each, $8; 17 Chinese business houses at $5 each, $20; 4 Chinese tan games at $10 each, $40; is said to receive from the OR&N Co., $40, Walter Keyes' Yankee Bazaar, $5 per month, from the city of Portland, $1 per month; total per month $220.

Estimated amount received by special officer Mott: Beat, east of Fourth from Morrison to Taylor streets; 63 white business houses, $83; 20 Chinese stores at 50 cents each, per week $10, 34 bawdy houses $170; Chinese gambling houses at $4 per week each, $96; from the city of Portland per month, $1; total per month, $390.[91]

To put this in some sort of perspective, the average wage of a factory worker at this time was about $1.35 per day. These special police became wealthy men, as did the men who supervised their activities. These conditions would continue until the turn of the century, when investigations were conducted and a grand jury accused the special police, the chief of police and the sheriff of corruption. The fight to suppress vice in Whitechapel and corruption in the city government took many decades and is a subject for a book much larger than this one.

CHAPTER 8

THE BONEYARD AND SCOWTOWN

The old OR&N Co. boneyard (originally the OSN Co.), directly upstream from the North Pacific Lumber Company's long wharves, had been the graveyard for many a fine vessel. For over half a century, the boneyard served as a maritime recycling center, where valuable parts could be salvaged and used to repair working vessels. During these years, it changed hands a few times—its last owner being the Union Pacific Railroad, which acquired it when it purchased the majority shares of the OR&N Co. in 1892.

Although it began its life as a junkyard for steamboats, by the end of the 1870s, the boneyard was also a serious shipyard. There were two "ways" or cradles for building steamboats that were twenty-five feet wide and fifty feet long. Building ships in the same location where ships were broken apart was a convenient way to salvage pieces of old steamboats. Some of the sun-bleached hulls of famous old riverboats lasted for many years and served as landmarks at the edge of town. Old-timers carried fond memories of the swimming hole at the north end of the boneyard where skinny-dippers jumped off the hulls into the river.

The jumble of ruined hulls and pilothouses covered with brambles was a last refuge for homeless people of all sorts. In the 1870s, the newspapers mention a prostitute named "Boneyard Mary" who lived among the scows lining the boneyard and became the sole witness to a murder. The boneyard was one of the first places police would search for fugitives, sometimes coming across groups of homeless boy squatters, lads the papers called

Scowtown visible in the distance on the east bank near the Inman Poulsen lumber mill. *Singer Sewing Machine Co. trade card.*

"street Arabs" or "urchins." These lads lived either by pilfering or working at low-paying jobs, such as selling newspapers on the streets.

One of the few writers to mention the homeless people inhabiting the boneyard was *Oregonian* editor Harvey Scott in his description of the scows moored along the shore.

> *Old skeletons of mighty ships—or shallow river crafts—lie white and dry on the embankment. Scant trees, usually shaking in the river breezes, of such deciduous growth as balm or oak, lend grace to an eerie looking shore. There are various river crafts tied up or moored along, or hauled up on the sand, some of which are occupied by families whose cook stove smokes ever curl and blow, and whose red and white garments washed and hung out to dry, ever flap in the breezes.[92]*

The boneyard met its end as a casualty of war. As the dark clouds of the Great War swept over the land, the need for another shipyard along the Willamette spelled its doom. The Foundation Company, a New York shipbuilding firm, acquired the boneyard property in July 1917, three months after the United States entered the war. It came to Portland with contracts to build forty wooden steamers for the French government. Within a few

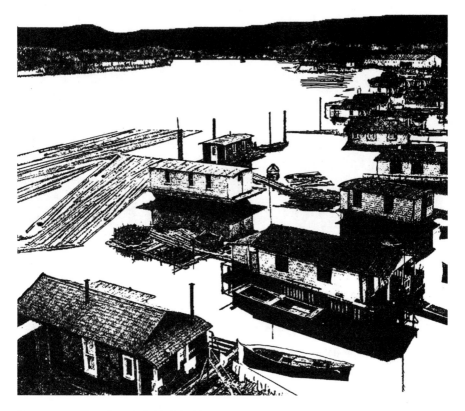

Scowtown by Ross Island. *Pacific Monthly.*

weeks, the shipbuilding ways were constructed, and the historic boneyard faded into dim memory.

SCOWTOWN

There were at least five areas along the Willamette that were used by squatters living on the water. These places were referred to collectively as "Scowtown." The farthest north was in a slough downstream from the North Pacific Lumber mill; a short distance upriver was the scowtown at the boneyard. Then there were neighborhoods along the east bank from below the Steel Bridge all the way down to the south end of the Inman-Poulsen

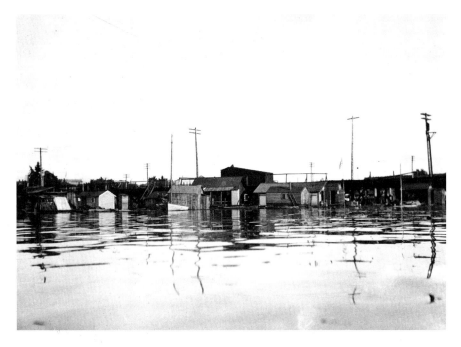

Scowtown photographed from the swing span of the old Steel Bridge. *Copyright Thomas Robinson.*

mill, at the foot of East Grant Street. The scows, as they were called, were anything from a floating shack, such as Huckleberry Finn may have manned, to cozy little houseboats complete with rose arbors. These scows were homes to working-class families, single men and anyone wanting freedom from rent and taxes.

An interesting look into the lives of the people of Scowtown came Christmas morning in 1907. The *Oregonian* told a tale of how the day before some of the society women from Nob Hill ventured down to police headquarters and asked Captain Moore if he would point them to some families in Scowtown who needed some Christmas cheer in the form of money and provisions. The captain sent some men down to investigate. When the men began to make inquiries, they were laughed at and the "offers of charity were repulsed." The officers discovered that many of the scows were inhabited by longshoremen, mill hands and the like, earning good wages. Each day a sternwheeler grocery boat came by selling meats and vegetables.

Irving Dock

Columbia Dock No. 1

Montgomery Dock No. 2

Three grain docks redrawn by the author from images found in the *Morning Oregonian*, January 1, 1902.

Of course, not everyone in Scowtown was an honest working person. There were as many crimes committed in Scowtown as in any other fringe neighborhood. There is a legend in Portland about a woman named Nancy Boggs who ran a brightly painted, two-storied "whiskey scow" that also served as a bawdy house. This was one of the stories that Stewart Holbrook made famous in a bit called "The Three Sirens of Portland," first published in the *American Mercury* and repeated ad nauseum ever since. No doubt there were blind pigs (illegal saloons) in Scowtown, and it is almost certain that there were also houses of ill fame, but Nancy Boggs had her saloon on Pine Street listed in the city directory for many years. I am of the opinion that Scowtown was not a classy place, and classiness was a big priority with a lady like Nancy.

In 1909, after numerous complaints by riverside property owners, Mayor Simon started to take steps to move the river dwellers away from the city to areas upriver on the east side from Ross Island to Sellwood. Some of the houseboats were moved by a contractor to cheap plots of land located as far from the city as the rural district of Lents. It would be a fun project for a sunny afternoon to ride around Lents on a bicycle hunting for cottages that look like they once were perched on a scow that floated somewhere near the bridges. Naturally this attempt to move Scowtown out of Portland was resisted at every front. Sometimes the police would cut scows adrift and move them away from the complaining landowner's property, and occasionally the scows were set afire—especially if they were mud bound on a bank and could not easily be moved. At the beginning of the 1910 census, it was believed that there were at least five thousand people living in scows along the wharves and banks of the Willamette within the city limits of Portland.

The scows eventually gained some level of respectability (if not popularity) as property owners took the initiative to establish more permanent wharves with spaces for which they could charge rent. Over time, all of the scows ended up at houseboat landings, with city water, sewer and electricity, and in 1919, the U.S. mail began to be delivered to these areas by mail boat.

CHAPTER 9

WARSHIPS ON THE WILLAMETTE

THE PACIFIC SQUADRON AND THE BATTLESHIP OREGON

The earliest U.S. naval excursion on the Willamette River was that of Captain Wilkes in 1841—a surveying mission for the U.S. Coast and Geodetic Survey. This was accomplished by use of a rowboat loaned to the expedition at Fort Vancouver. They rowed in this "barge," as they called it, up to the Willamette Falls. In 1846, the navy frigate *Shark* was ordered to Oregon to offset the show of naval force the British had in the area. By that time, the charts Wilkes had made were already outdated by the shifting sands of the river. The *Shark* anchored in the mouth of the Willamette but was unable to enter due to the shallowness of the river.

Oregon pioneers who hoped to see the land they settled become a part of the union were promised by then Secretary of State Buchanan that they would be visited by U.S. Navy warships. Much to the disappointment of the settlers, the vessels were not forthcoming. In 1848, they bemoaned this fact, and wondered if the U.S. government had left them on their own.[93]

During the 1880s, the U.S. Navy began to replace its old sailing ships with up-to-date armored cruisers. In 1890, the contract was awarded to Union Iron Works in San Francisco to build a battleship that would be named the USS *Oregon*. The vessel was launched in

USS *Oregon*, with the six-pounder gun and crewmen. *Library of Congress, Prints & Photographs Division, Detroit Publishing Company Collection, LC-D4-20838.*

1896, and because of the threat of war with Spain, she was sent to join the North Atlantic squadron.

Oregonians followed the adventures of their namesake battleship with an admiration bordering on worship. The city presented the ship with a silver service and the officers with swords. Models of the vessel were a common sight, including rose-covered floats in parades, such as the Rose Parade.

Even though the battleship visited dry docks in the Puget Sound on several occasions, naval officials were reluctant to bring the vessel into the Columbia until after a period of deep dredging made possible by the Rivers and Harbors Act. Finally, in the summer of 1925, the well-loved symbol of Oregon's patriotism sailed across the Columbia River bar, up the 111 river miles to the mouth of the Willamette and on to Portland—gliding into a

USS *Boston*, the first ship assigned to the Oregon Naval Militia. *Library of Congress, Prints & Photographs Division, Detroit Publishing Company Collection, LC-D4-20151.*

temporary berth at Terminal No. 4, before sailing into Portland with Queen Suzanne I of Rosaria to join in the celebration of the Rose Festival. The grand battleship was accompanied by six submarines and the submarine tender USS *Savannah.*

THE OREGON NAVAL MILITIA

The *Oregon* was not the first modern naval warship to be seen sailing on the Willamette River; in fact, Oregon had its own navy, or at least something called the Oregon Naval Militia. In 1898, Oregon was selected as one of the states to form a Naval Militia. This waterborne militia was placed under the control of the Oregon National Guard. Three units were formed: one

USS *Marblehead*, one of the warships used by the Oregon Naval Militia. *Library of Congress, Prints & Photographs Division, Detroit Publishing Company Collection, LC-D4-2107552.*

in Astoria and two in Portland. The U.S. Navy loaned the State of Oregon the two-masted, steam-powered, protected cruiser *Boston*, built in 1883 as part of the "squadron of evolution."[94] This magnificent vessel was used as a training ship by the militia and was normally moored in Portland at the foot of Jefferson Street. The militia units would train on weekends throughout the year, but in the summer, they were permitted to take their ship for cruises on the open sea.

In June 1916, the *Boston* was replaced by an equally magnificent vessel: the *Marblehead*, an unarmored cruiser. These vessels also had a marine detachment, a militia mostly made up of seniors from Jefferson High School. Early the following year, the torpedo boat *Goldsborough* was loaned to the militia. This vessel had been built in Portland by the Wolff & Zwicker plant on the east end of the Morrison Bridge. When war was declared two months later, naval militiamen were taken into the regular U.S. Navy. After World War I, the Oregon Naval Militia was formally disbanded on December 8, 1921. The state-owned launch, the *Penguin*, which was used for harbor patrols and training sessions, was sold for $5,000, bringing an end to Oregon's own navy.

Festival Warships

During the balmy month of September in 1903, the Multnomah Club Carnival drew thousands of fun-seekers. The navy cruisers *Marblehead* and *Concord* were sent to Portland for the occasion.

The *Marblehead* returned in June 1905 for the Lewis and Clark Fair, anchoring in the harbor upstream from the Steel Bridge. The Sunday afternoon of June 11 was unseasonably hot, and festive spirits were at their highest. Fair-goers headed to the river in droves to cool off. It was estimated that fifteen thousand people were on the river that afternoon in a variety of watercraft, viewing the *Marblehead* and visiting the amusements at Oaks Park. The following week, after the departure of the *Marblehead*, Pacific Squadron cruisers *Chicago* and *Boston* and the torpedo boat *Perry* moved into an anchorage above the Steel Bridge. Visitors to the ships were brought by launches from the Stark Street dock. The fair was also visited that summer by the Italian warship *Umbria* and the German cruiser *Falko*. However, none of these true-to-life vessels could compete with the excitement of the naval battles that took place in the evenings on Guild's Lake, the centerpiece of the Lewis and Clark Fair. These staged reenactments of famous American

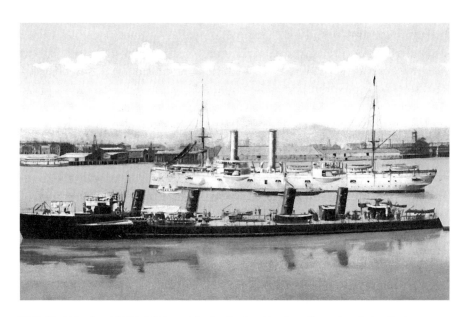

USS *Marblehead* and USS *Goldsborough* in the Portland harbor. *Postcard, author's collection.*

USS *Charleston* receives visitors at the first Rose Festival. *Postcard, author's collection.*

victories at sea used realistic-looking models of navy ships and made the West Hills echo with the blasting of their "big guns."

Two years later in mid-June, the first annual Rose Festival was celebrated with great enthusiasm. The navy cruiser *Charleston* and the torpedo boat *Paul Jones* were sent to honor the celebration. The *Charleston* was the flagship of the Pacific Squadron under the command of the dignified but sad-eyed Admiral Swinburne, who was suffering an intense bout of rheumatism during the visit. The vessels were anchored in the river, near the Stark Street dock, which had been turned into a bower of roses for the occasion.

Over the years, the Rose Festival Fleet became so much a part of Portland tradition that a Rose Festival without warships would seem very odd. In years when naval vessels are unavailable due to military activity in other parts of the globe, the Army Corp of Engineers brings down a few workboats from their moorage by the Saint Johns Bridge. From as early as the summer of 1921, Canadian naval vessels have been a regular part of these festivities, a gesture of an abiding friendship with our close neighbor.

TYPHOID RIVER AND BULL RUN

I n the early years, private companies supplied Portland with water from various creeks and springs along the hills, as well as from reservoirs of water pumped from the Willamette River. None of these systems were reliable. The creeks went dry in the summertime, and pumping systems could not keep up with the growing demand. The main water supply was from a pumping station near the foot of Jefferson Street. When pollution by sewers became a problem, the pumping station was moved to a place south of the "White House." This was near what is now the Sellwood Bridge. The brick ruins of this station were incorporated into the foundation of a recently constructed mansion and can be seen from across the river at the Waverly Country Club golf course.

As strange as it might seem to us today, the waters of rivers, such as the Willamette, were once seen as a sort of natural force that could dispose of all the waste created by humans. It was as though the river's flowing water could carry whatever it was given down to the infinite ocean. There was even a mindset that sewage would be cleaned by running water and that a river could be considered a source for drinking water, even if there were towns upstream using the same river as a sewer.

Once these attitudes started to change, the City of Portland formed a water committee to decide on the best solution. A pristine mountain lake with the ill-fitting name Bull Run was chosen as the ideal source for the city's drinking water. Not everyone was pleased; some thought it was a foolish waste of tax dollars, while others resisted the idea of using public

Boathouse and swimming area in the Willamette River at the Oaks. *Postcard, author's collection.*

money. When in 1889 the Oregon legislature approved the "Bull Run Water Act," allowing bonds to be sold and taxes levied for its completion, it was vetoed by Governor Pennoyer. The Democratic speaker of the Oregon house (and later, governor) T.T. Geer wrote this in the Salem *Evening Capital Journal*:

> *We do not now recall an instance in the history of this country since the passage of the Stamp Act of 1765, and the resulting "Boston Tea Party" which constituted such a flagrant outrage on a free people, as the attempted enactment of the Bull Run water bill by the republican party in the last legislature, and but for the gallant stand of our revered governor our people would today be deprived of the last vestige of human rights.*[95]

In spite of fierce opposition, the Bull Run water system was put in place—an enormous project, but one that has been a blessing to the city ever since. As it happened, around the time of the completion of the Bull Run system, outbreaks of typhoid fever began occurring around the Willamette valley, where many of the towns and villages were still using

View to the east toward Bull Run Reservoir. *Singer Sewing Machine Co. trade card.*

river water. There was still a great deal of disbelief that the disease came from river water, but the health officials of the state were convinced. A poem attributed to Dr. Woods Hutchinson, director of the State Board of Health, was circulated to the newspapers. It was a parody of a well-loved poem that was learned by heart and recited by school children: "Beautiful Willamette," written by Samuel L. Simpson.

Here are the opening verses of Dr. Hutchinson's version:

> *The Beautiful Willamette*
> *From the Cascades' frozen gorges*
> *Leaping like a fiend at play*
> *Blacker, toxic, through the Valley,*
> *Dark Willamette glides away.*
> *Onward ever.*
> *Murky river.*
> *Rolling sewage to the sea,*
> *Time that scars us.*
> *Maims and mars us.*
> *Is a child compared with the;*

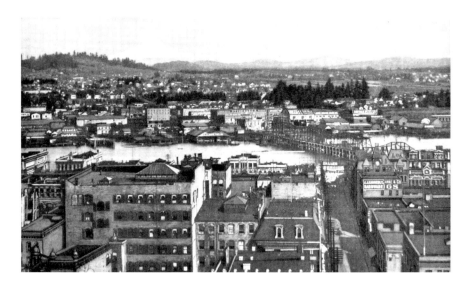

Beautiful Willamette, for many years both a source of drinking water and a sewer. *Singer Sewing Machine Co. trade card.*

> *Typhoid's witchery is planning*
> *Tomb and graveyard for thy side*
> *Fever ever haunts thy journey,*
> *Microbes wobble in thy tide...*

And so it rolls, terrible verse after terrible verse.

In 1895, once the pure waters of Bull Run poured through the faucets in the city of Portland, typhoid cases in the city dropped dramatically, proving men like Dr. Hutchinson right—although he still had plenty of detractors.

On into the twentieth century, it was common to swim in the Willamette River, even after sewers and factories had made this a dangerous activity. Throwing refuse in the river was also so common that it even interfered with river traffic at times, and a dredge needed to be called in to remove the waste from the shipping channel. As shipbuilding and other heavy industry built up around the river, the health of the river was rarely given a cursory thought, especially in the desperate years around World War I, the war that they called the "war to end all wars."

WILLAMETTE RIVER
SHIPBUILDING WAYS

The first ship to be built on the Willamette was constructed in 1840, before the first cabin had been built in the clearing that was to become Portland. The vessel was named the *Star of Oregon*, a fifty-three-foot fore and aft schooner. It was built by a mountain man named Joseph Gales, with the help of Captain Wilkes, the U.S. Navy explorer who had been mapping the region. Gales had been a seaman and had enough knowledge of shipbuilding and navigation to be successful at this venture. The vessel was built for the express purpose of bringing cattle to Oregon. Cattle provided many of the items that were obtainable only through the Hudson's Bay Company, so it was company policy not to supply cattle to settlers. Gales's plan was to build a ship valuable enough to trade for a herd of cattle in California and then to drive them to Oregon overland. Interestingly, the site chosen for building this schooner was a place near Swan Island, where many hundreds of ships would be built in later years. As cockeyed as the plan might sound, it worked.

From the earliest days in the life of the city of Portland, building rowboats, sailboats, steamboats and barges of various sorts had been one of the city's important but minor industries. By the 1880s, as maritime commerce grew and the river was dredged deeper, shipyards were an established part of the landscape. Wherever there was a shipyard, large timber cradles called "ways"—the structures in which the ships were built and launched—stood like unfinished skyscrapers along the shore. In later years, the ways would be enormous and constructed from concrete and steel.

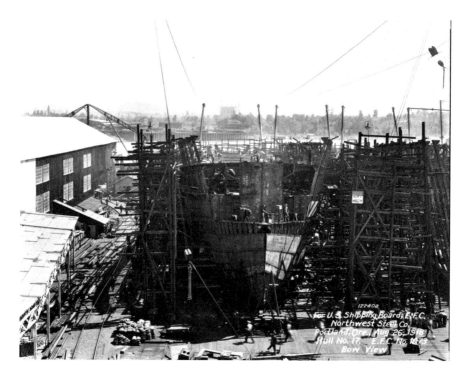

Northwest Steel World War I shipyard south of the Steel Bridge. *Copyright Thomas Robinson.*

DRY DOCKS

In the 1890s, the Portland Chamber of Commerce began to tackle the problems arising from the fact that Portland did not have a suitable dry dock. In 1883, the Oregon Railway and Navigation Company had built a four-hundred-foot dry dock north of the flour mill at Albina, but this facility had fallen into disuse after a few short years. In 1890, a U.S. Naval committee decided on Port Orchards, on the Puget Sound, as the location for a large naval dry dock. The disadvantages of the Columbia River bar and months of low water levels had turned the decision away from building on the Columbia River. After years of political opposition and infighting, the Port of Portland was finally able to open a floating dry dock

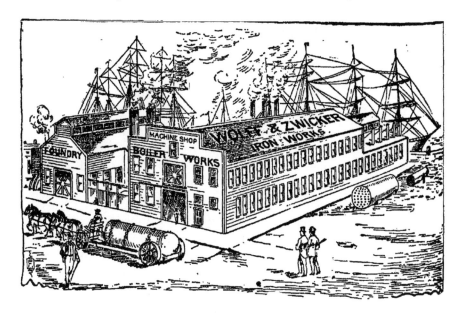

Wolff & Zwicker Iron Works, at the east end of the Madison Street Bridge. *Morning Oregonian.*

at Saint Johns in 1904. This dry dock was capable of lifting the largest ships ever seen at the port, ships up to five hundred feet long and weighing ten thousand tons, deadweight.

In 1889, there were four shipyards in Portland, providing employment for around ninety men. By the turn of the century, Portland had attracted several even larger firms. Three of the yards building wooden-hulled vessels were located close together on the east side: Joseph Supple (later Supple, Ballin) at the foot of East Belmont, Lewis Pacquet at the foot of East Alder and Hale & Kern at the foot of East Market. This grouping of ways, rising next to the double-decked wharves, with Mount Tabor and Mount Hood beyond would have made an interesting sight from downtown windows looking out on the Willamette.

WOLFF & ZWICKER

The serious and sustained efforts to establish Portland as a major seaport began to pay off in a new way for the city as the twentieth century approached. It was now a port with a deeper channel, a history of shipbuilding and several large iron works. In 1896, the Wolff & Zwicker Iron Works, with a plant on the east approach of the Madison Street Bridge, came to the notice of the U.S. Navy. The company had some of the most advanced machine shop equipment on the Pacific coast and had successfully completed the enormous task of providing steel conduit for the Bull Run water project that carried water to the city from a lake near Mount Hood some forty-one miles away. This was during a period of U.S. Naval build-up preceding the Spanish-American war. The Wolff & Zwicker company was at that time commissioned to build two torpedo boats, two lightships and the destroyer USS *Goldsboro*. The company also built a small steel-hulled steamer for the Alaska Packers Association. Even though the naval contracts were filled to the satisfaction of the government, the shipyard was operated on too slim a margin and went into receivership in 1900.

WILLAMETTE IRON AND STEEL WORKS (LATER WISCO)

During World War I, Willamette Iron and Steel Works, which had been in the steamboat business since the 1860s, was contracted to build a variety of smaller naval vessels, such as minesweepers and torpedo boats. Its central location, a few blocks north of Burnside between Flanders Wharf and the Gas Company dock, made this company a fixture of the Portland west riverbank, appearing in hundreds of photographs taken from the east bank and from the bridges. Eventually the company moved its operations farther up to the 2800 block on Front Street, where more room was available. This company, started by pioneers and once owned by H.W. Corbett, continued building small commercial and naval vessels, locomotives and other heavy equipment long into the twentieth century.

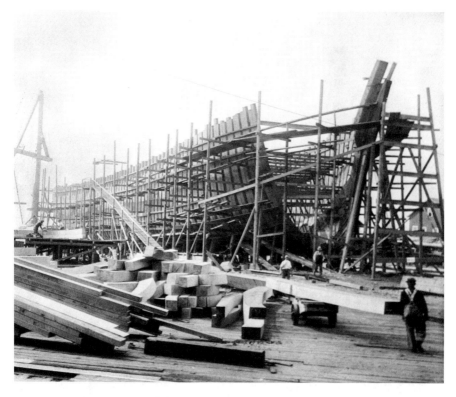

Wooden ships at Supple & Ballin Yards, on the east bank of the Willamette. *Library of Congress, Prints & Photographs Division, Bain News Service, LC-DIG-ggbain-24747 60.*

ALBINA ENGINE & MACHINE WORKS

Another firm that would last for years to come was the Albina Engine & Machine Works at the foot of Albina Street, near the ferry landing. This company was started in 1907 by a Portland engineer in an old livery stable. About the same time, the Albina Marine Works started business two blocks north with designs toward building steamship boilers, fabrication and steel ship repairs. During World War I, the two companies worked together winning valuable navy contracts. Albina Marine constructed the hulls; Albina Engine & Machine Works built the engines and propulsion systems. In the later years, the companies would merge to build steel ships of all sorts throughout most of the twentieth century.

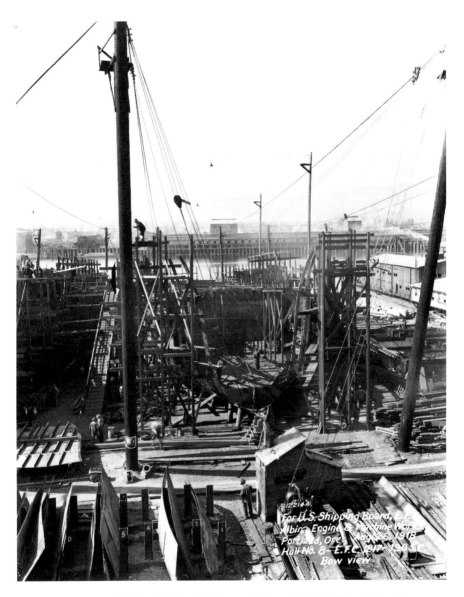

Albina Engine and Machine Works building steel ships for World War I. *Copyright Thomas Robinson.*

Tall Ships, Steam Mills and Sailors' Boardinghouses

THE GREAT WAR ON THE WILLAMETTE

When the Panama Canal opened in 1914, it cut in half the distance for shipping from the West Coast to Europe. Two years later, when the "Great War" began to be played out on seas and battlefields at the opposite side of the world, the canal brought the battle nearer by half as well. The Pacific Northwest was now close enough to be a supply center for a European war. One of the main scarcities during this war was steel, and Portland, being both a great lumber center and a city with several large shipyards for building wooden-hulled ships, became a shipyard city almost overnight. The shipyards of World War II—especially the large Kaiser yards at Swan Island—have overshadowed the memory of Portland as a shipyard center for the first Great War. Portland's contribution to that war was great, and the city's establishment as an excellent location for shipbuilding was secured during those years.

During the war period, the U.S. government put shipbuilding under the direction of a quasi-governmental agency called the Emergency Fleet Corporation. Between 1914 and 1918, German U-boats sank a grand total of 12,850,815 gross tons of allied and neutral shipping. It was vital to the war effort to stay ahead of the U-boats and provide more ships than they were able to sink. In 1916, there were four thousand men in Portland directly employed in the shipbuilding industry; by 1918, that number had risen to forty-two thousand.[96] From June 1917 to June 1919, 227 vessels were launched from the marine ways in Portland.

Steel-hulled vessels	No. of ways
Northwest Steel Co.	4
Columbia River Shipbuilding Corp.	4
Albina Engine & Machine Works	4
G.M. Standifer Construction Corp.	5

Wooden-hulled vessels	
Grant Smith-Porter Ship Co.	8
Supple-Balin Shipbuilding Corp.	4
Peninsula Shipbuilding Co.	4
Coast Shipbuilding Co.	4
G.M. Standifer Construction Corp	4
Kiernan & Kern Shipbuilding Co.	1
Columbia Engineering Works	4
Foundation Co.	10

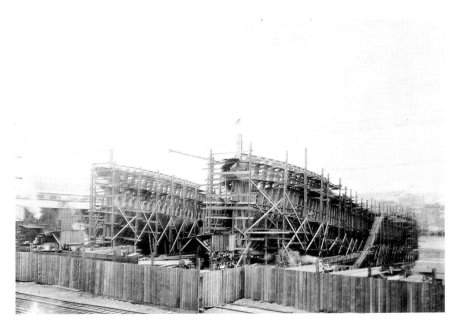

Wooden hull for a steamer being built at the Peninsula Shipyard during World War I. *Library of Congress, Prints & Photographs Division, Bain News Service, LC-DIG-ggbain 24745.*

Portland was less prepared for the influx of workers heading for the shipyards than it was for building the ships themselves. There had been an earlier rise in the population in the years following the Lewis and Clark Fair, but with tens of thousands needed for the shipyards and many more in supporting roles, the shipyard companies were looking high and low for places for their new workers to live. The following is just one of such advertisements in the classified section of the *Oregonian* in October 1918:

> *G.M. Standifer Construction Corporation*
> *To build ships we must have men. To have men we must have housing and accommodations. We ask every patriotic citizen who has a house or rooms for rent to phone or mail information to our employment bureau.*

Columbia Dock No 1

Portland Flouring Mills

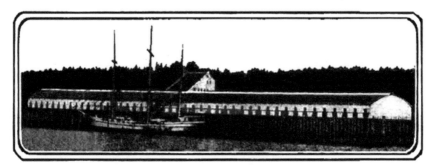

Oceanic Dock

Three grain docks redrawn by the author from images found in the *Morning Oregonian*, January 1, 1902.

After the War Was Over

Before World War I, there were still persistent notions in maritime circles that Portland was not a "real" seaport, that the Columbia River bar was a treacherous killer of ships and that vessels venturing to that port were likely to be stuck on a sandbar somewhere between Swan Island and Astoria. The achievements of the shipyard on the Willamette River helped to change this perception and allowed the Port of Portland to imagine a bold new seaport designed for the needs of the twentieth century.

CHAPTER 12

WORKERS ON THE WATERFRONT

It is beginning to look like old times. Nearly every vessel arriving has made a long passage. There is room and wheat for many more here, and the more that come the better pleased the stevedores and longshoremen will be. They have had an easy, idle time of late.

That remark from the *Oregonian* on October 29, 1885, shows how the low waters of the river affected the whole city—not only the wharfingers, stevedores, longshoremen, tugboat men, barge men and steamboat men, but also captains and owners of vessels who depended on the river for their livelihood. The notoriously dry months for the Willamette River were late August through late October, a fact noted in port manuals and shipping schedules around the world. This year was a fortunate one—the rains came and the floods rose earlier in October.

From the early days of Portland, men who worked at the longshore trade organized to improve the conditions of their lives. Before 1870, the work would have been aboard coasting vessels, mostly steamboats and—until the arrival of bulk grain cargo carriers in the twentieth century—the largest part of the job of loading ships involved struggling with heavy sacks of wheat and flour. Equally difficult would have been the job of removing ballast from sailing vessels. This ballast was made up of sand and rock (sometimes paving stones) and was unloaded at various ballast docks along the river. This work was done under the direction of highly skilled stevedores and riggers, as was the work of securing the vessel to log rafts to keep it stable once the ballast was removed. Longshore work was not only

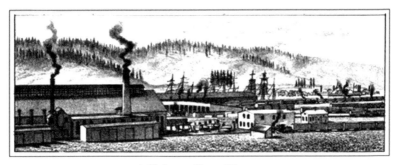

Albina Car Shops

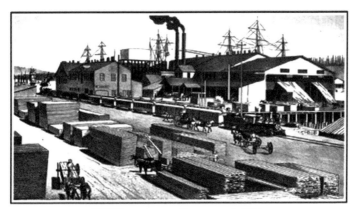

Willamette Steam Mills

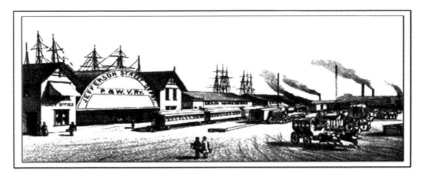

Jefferson Street Terminals

Images from various 1888 editions of the *West Shore* magazine.

physically hard and dangerous, but it was also low-paying. It was difficult for longshoremen to afford the basic needs of a family. Many of them lived in shacks on scows along the riverbank.

One of the early longshoremen's organizations in Portland was called the Longshoremen's Protective Union, reported in May 1868 as having a torchlight parade complete with a marching band. Little else is known about this ad hoc society.[97]

In those days, the head stevedore was often a retired ship's captain who was not only in charge of loading the vessel but also of hiring the longshore gangs and overseeing their pay. In Portland, a Captain J.G. Fairfowl was one of the more prominent of that group. In 1877, Captain Fairfowl found himself embroiled in a dispute between the longshoremen over the issue of premium pay for working nights and Sundays. This dispute became overly heated, and a strike was called by one of the groups of longshoremen. Threats of violence were made against Fairfowl and any longshoremen who would try to break the strike. On the evening of November 7, 1877, as Fairfowl was conducting a group of men to work at an Albina dock, he was met by an angry group of longshoremen at the east ferry slip of the C.&O. railroad ferry. A near riot ensued, and the police were called. The leader of the striking longshoremen, a man named Pat Hoague, was arrested and fined fifty dollars (over three weeks wages). This incident accentuates the divided nature and weakness of the waterfront workers in those days.[98]

In 1878, in an effort to unite two divergent groups, the longshoremen and the riggers merged to form the Portland Longshoremen and Riggers' Benevolent and Labor Union. This new union was formed not only to act in hiring and mediation of wages, but also to provide funerals for its members. It seems from the context that longshoremen were too poor to bury their dead and needed to ask local merchants to help pay for the funerals.

The day after the formation of the union was announced, the *Portland Bee* published a rebuttal by some dissenting stevedores, who were quoted as calling this a "spurious union." One of the founders of the union, P.D. Lyons, responded in the *Oregonian* with a long, emotional reply, part of which reads:

> *The union is got up for the benefit of ourselves so as not to be going around like [sic] with a subscription list to merchants and everybody else. It is certainly near time that we do some good for ourselves and have this thing of*

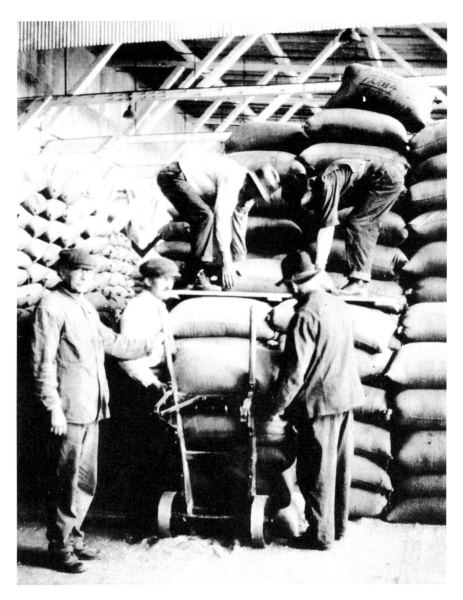

Longshoremen in a Portland export grain warehouse. *Courtesy Agricultural Marketing Service.*

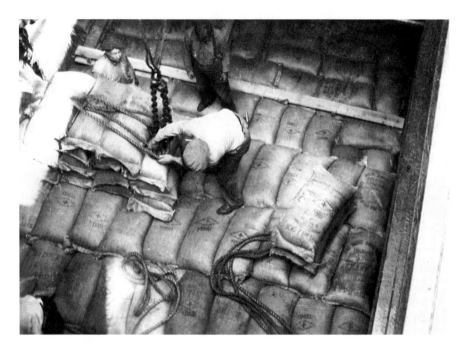

Longshoremen stack wheat sacks in the hold of a vessel loading at a Portland grain dock. *Courtesy Agricultural Marketing Service.*

begging stopped for burying our dead by subscription. Our constitution says that those who shall become members of this organization shall be good, sound, hearty men, able to perform their duty—not to load ships with their mouths, but muscle and good labor.[99]

And so, with a rocky start, the Portland Longshoremen and Riggers' Benevolent and Labor Union went to work for its members. The labor struggles of the later part of the nineteenth century were fierce in some parts of the country, pitched battles with weapons wherein there were many injuries and deaths. Because of its relative size and distant location from the large, industrial cities of the East, Portland was insulated—to a large extent—from these events. However, the sorrows of poverty, the shame of racial hatred and the unrelenting greed that fueled these wars were constantly present in this city as well. During this time in the Pacific Northwest the labor unions saw one of their main objectives as being the exclusion of Oriental, especially Chinese, labor. Large numbers of Chinese

PORTLAND'S LOST WATERFRONT

workers had helped to join the opposite shores of the nation by building railroads, but once those railroads were built, the Chinese workers had to look elsewhere. All across the West, communities took a stand against Chinese labor. Some of this hatred was due to self-preservation, but mostly it was just blind prejudice against people of different appearance, language and customs.

In 1870, the Fifteenth Amendment to the U.S. Constitution ensured that every (male) citizen would have the right to vote, regardless of "race, color, or previous condition of servitude." H.W. Corbett, the senator from Oregon, had recommended that the amendment include the words, "But Chinamen not born in the United States, and Indians not taxed should not be deemed or made citizens." His suggestion never made it into the amendment. But in 1882, anti-Chinese fervor in the United States caused Congress to pass the highly discriminatory Chinese Exclusion Act, wherein all Chinese people—with the exception of travelers, teachers, merchants, students and those who were born in the United States—were barred from entering the United States. The law also prohibited Chinese residents, no matter how long they had legally worked in the United States, from becoming naturalized citizens.

In 1886, a strike by the Coast Seamen's Union resulted in a joining together of powerful West Coast shipowners into a group called the Ship Owners' Protective Association of the Pacific Coast. From then on, the battle of wits and will was intensified, with strikes being suppressed, oftentimes before they even started. The waterfront workers were divided into four different groups that ended up constantly battling over jurisdictions instead of cooperating for the good of everyone.

During the 1880s, the issue of Asiatic seamen on coasting vessels became an issue with the longshoremen. It was an issue that would continue on as striking seamen were replaced by Asian workers who were willing to work according to the subsistence wages and long watches required by the companies. In the official report of the Congressional Transportation Committee in 1890, the head of the Coast Seamen's Union, Andrew Furuseth, stated for the record:

> [A]bout one-fourth of the American merchant marine is manned by Asiatic seamen, Japanese, Chinese, Lascars or East India sailors, and Tangals or "Manila men," together with Turks and Arabs. Even in the coastwise trade, although the vessels must be American, there is no such requirement as to seamen, and on the Pacific coast not more than 10

Workers at the rail yard near Crown Mills, circa 1912. *Copyright Thomas Robinson.*

*percent are American born. On that coast the Scandinavians, including
with them the Finns, probably predominate; next would be the Germans,
and Americans last of all.*[100]

In 1906, as labor troubles increased along the coast, Portland mill
workers and longshoremen banded together to refuse to handle cargo on
ships manned by Oriental replacements of striking sailors. P.D. Hall, the
secretary of the Portland Longshoremen's Union was given the task of
visiting incoming coasting vessels to see if they were manned by Oriental
crews. This was a new twist to a battle with the shipowners. Longshoremen
and seamen had long fought battles to decide which group was allowed to
handle the cargo, and at what point one union encroached on the rights of
others. Over the coming years, the mariners and longshoremen would find
that the only way forward was to cooperate with each other.

At the turn of the last century, the largest employer on the waterfront
was the Union Pacific Railroad, the company that bought out the OR&N
Co. This company owned large wharves and handled a tremendous

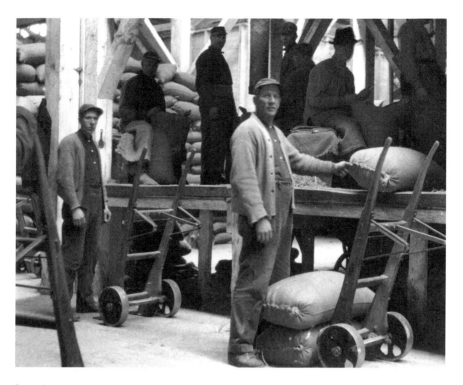

Longshoremen pose while loading heavy sacks of wheat onto hand trucks. *Courtesy Agricultural Marketing Service.*

amount of freight on its trains, ferries and steamers. During the latter part of the century, several large strikes were waged against the company by the Knights of Labor, a group to which the Portland Longshoremen were now affiliated. The leader of this group was a longshoreman named Edward Teesdale, a man who became the target for ridicule by anti-union newspapers. He was referred to as "he of the tapering finger and soft hands who chins it for a living as a champion of labor." He was seen as ineffectual, and after a large strike against Union Pacific came to an unsatisfactory end in 1894, he was unable to get the strikers' jobs back after they were blackballed by the company.

It would be years before the longshoremen unions of the Pacific Coast were united and able to obtain a family wage and good benefits for waterfront workers. In the meantime, there were headlines like this one from August 1, 1900: "Strike Not A Success: Longshoremen Are Firm, but Docks Are All Working."[101]

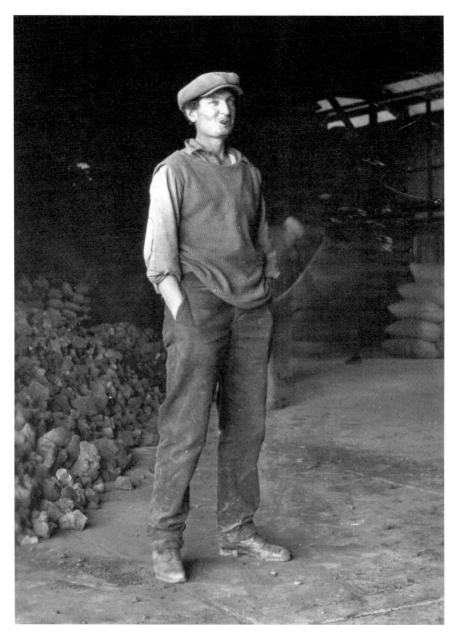

A longshoreman with an unlit cigar stub in his mouth standing in a warehouse next to bunker coal and sacked wheat. *Courtesy Agricultural Marketing Service.*

By 1911, longshoremen were making $4.95 per day, working nine to ten hours. This may seem like a lot compared to other jobs at the time, but certain things must be taken into consideration.

1. The "shape up" system of hiring, as it would come to be called, such as the system seen in the famous Kazan movie, *On the Waterfront*, starring Marlon Brando. Longshoremen were hired according to a system of graft, kickbacks and favoritism.
2. The work was not steady, and whatever money was made in the shipping season needed to last through hard times.
3. These jobs included none of the benefits of room and board, like some other labor-intensive jobs, such as logging or even being a seaman aboard ship.

A time would come when both the American merchant mariner and the American longshoreman would be highly paid and well respected—the envy of many of their peers. This time would not come until the country was heading toward the brink of World War II, a time of undreamed of advancements in science and engineering and unimagined horror in the machinery of war.

FINAL THOUGHTS

There are very few things remaining along the waterfront that would be recognized by, let's say, a riverboat pilot from the turn of the century. The "new" Steel Bridge was completed in 1912 and the Hawthorne Bridge completed in 1910, and the two remaining mill buildings, Albers and Crown (now Centennial), were built about that time as well. He would see that all of the wharves, boathouses, grain warehouses and docks were gone, replaced by towering cement company bins and grain elevators. If our riverboat pilot looked carefully, he might notice the red brick tower of the Union Station, peeping up from behind a line of condominiums where McCormick Dock once stood. If he traveled beyond the marvelous new Ross Island Bridge, he would see only the Inman house, with its conical Saint Anne's tower, to assure him that this was indeed Portland.

Just as the waterfront of yesteryear itself bears almost no resemblance to the waterfront of the present time, so the workers are equally transformed.

Instead of tight-knit guilds of white males, one will find a workforce made up of men and women from every ethnicity. Instead of gangs of muscled men hoisting 240-pound sacks of grain or loading trolleys with boxed cargo at a break bulk warehouse, machines perform the labor. The occupation of longshoring itself has been transformed from being a job belonging to the ill educated and poor to one that is a highly desired profession.

There is also no longer a certain "effluvia" rising from the waters, the sort of thing that would cause the ladies on the streetcars to put their handkerchiefs over their noses. The Willamette isn't clean enough to drink or even swim in safely, but at least it no longer stinks to high heaven. In my opinion, it was this smell that caused businesses to move back from the river and allowed the Department of Transportation free reign to build a freeway on the east shore, ruining it for years to come.

When the wharves and warehouses were destroyed, never to be replaced, and all the scows driven from the banks, a great deal of the city's charm was ruined as well. The west side fared better than the east and eventually became parkland—Portland's "living room," a place for feasts, celebrations and festivals of all sorts. Here—between where the OR&N Co. Alaska Dock and the City Gas Works once stood—there is also a park, lined with cherry trees, commemorating the suffering of Japanese Americans in World War II.

At the time of the writing of this book, there is a fine treasury of the bygone waterfront, the Oregon Maritime Museum, housed in the old sternwheeler tug *Portland* moored along the west bank at the place where the great Ash Street Dock once stood. Perusing the many fine exhibits of this museum, one can start to form a picture of just how different the city is today.

Looking into the future, only two things can be guaranteed to remain constant: Portland will always be spread across the roll of the same gentle hills, and it will always be divided by the same beautiful Willamette.

APPENDIX I

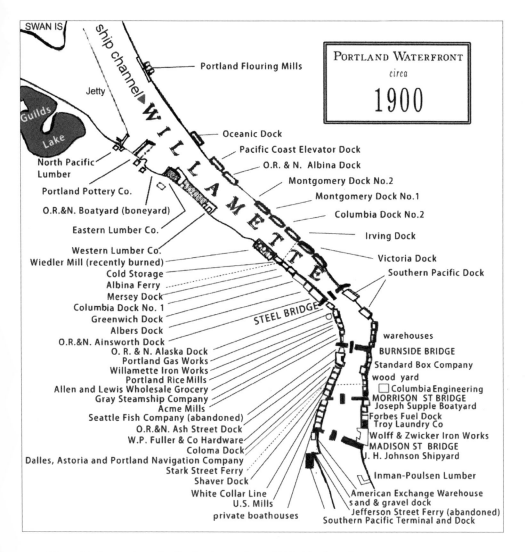

Map of industry along the Portland waterfront, 1900. *Map by author.*

APPENDIX II

The Willamette River Light Station

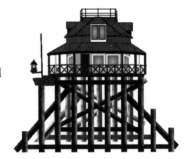

Completed January 24, 1896

Situated near the north end of Tom Island
on the east side of the Willamette River
at its junction with the Columbia River.

Fixed red lens lantern light and a fog bell.

The station was manned by a single light keeper until it was
electrified and automated in 1933.

The automated fog bell rang every 10 seconds during foggy periods.
The Light and fog signal were moved to a low piling near the Kelly
Point beach. The dwelling was acquired by the Portland Merchants

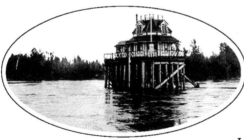

Exchange and moved to Kelly
Point. The house became
the station that informed the
downtown exchange by
telephone when vessels
entered the Willamette
heading for dock.
The dwelling was
destroyed by fire
June 14, 1957.

Willamette River Light Station. *Drawing at top by author, lower image from author's postcard collection.*

NOTES

CHAPTER 1

1. Wilkes, *Narrative of the United States*.
2. Letter to the editor, *Oregon Spectator*, July 9, 1846.
3. Ibid., October 15, 1846.
4. "Oregon Exports, & Etc—," *Oregon Free Press*, August 26, 1848.
5. "Improvements," *Oregon Spectator*, April 29, 1847.
6. *Stark v. Starr*, 94 U.S. 477 (1876).
7. Ibid.
8. *Oregon Free Press*, September 9, 1848.
9. *Oregon Spectator*, October 12, 1848.
10. *New York Times*, July 9, 1853.
11. Bowles, *Across the Continent*.
12. Richardson, *Beyond the Mississippi*.
13. Wright, ed. *Lewis & Dryden's Marine History*, 108.
14. Mills, *Stern-Wheelers up Columbia*.
15. *Morning Oregonian*, September 27, 1871.
16. MacColl and Stein, *Merchants, Money, and Power*, 154.
17. Wright, *Lewis & Dryden's Marine History*, 178
18. Queenstown, now called Cobh, is a port at the mouth of the river Lee, with Cork being eight miles farther upriver. Before the invention of the wireless telegraph, ships with cargoes of grain or sugar from the Americas

were sent to Queenstown to await further instructions. "Queenstown for orders" was one of the most common entries in merchant marine logbooks of the day.

19. *Report of the Secretary of War to the Second Session of the Forty-Second Congress,* Vol. II, 1899.

20. Throughout his career, H.W. Corbett would continue to be a strong proponent for using federal and state tax money to keep the channel dredged from Portland to the sea. In 1886, he convinced the National Board of Trade to recommend continual dredging projects to the president, even though opponents were inclined to point out that the grain transactions from Portland tended to profit the British grain merchants reselling to points in Europe more than the Americans.

21. *Report of the Secretary of War to the Second Session of the Forty-Second Congress,* Vol. II, 900.

22. *Morning Oregonian,* March 8, 1872.

23. "Organization of a Grant Club," *Morning Oregonian,* September 13, 1872.

CHAPTER 2

24. Tetlow, *The Astorian.*

25. "Introductory" *Tri-Weekly Astorian,* July 1, 1873.

26. In his memoirs, D.C. Ireland tells how the ballast from ships was used to fill in the land around the docks: "A good part of the town rests on rocks from Shanghai, yellow sand from Burma, volcanic ash from Alaska, and round river stones from England." With a ballast of sand from Scotland, Astorians created a beach for swimming.

27. *Tri-Weekly Astorian,* July 1, 1873.

28. "Commercial Statistics," *Tri-Weekly Astorian,* July 1, 1873.

29. Halloran, J.F., "As Others See Us," *Morning Astorian,* October 20, 1881.

30. Ibid.

31. *Report of the Secretary of War to the Second Session of the Forty-Second Congress,* Vol. II, 900.

32. At this writing, the depth is forty feet at "river stage" (height of a river measured from mean sea level or relative to a specific elevation called a "datum").

CHAPTER 3

33. "Early Navigation on the Willamette," *Sunday Oregonian*, November 18, 1900.

34. Delgado, *The Beaver*.

35. *Morning Oregonian*, January 1, 1876.

36. Patterson v. Eudora, 190 U.S. 169 (1903). "From the earliest historical period the contract of the sailor has been treated as an exceptional one, and involving, to a certain extent, the surrender of his personal liberty during the life of the contract. Indeed, the business of navigation could scarcely be carried on without some guaranty, beyond the ordinary civil remedies upon contract, that the sailor will not desert the ship at a critical moment, or leave her at some place where seamen are impossible to be obtained—as Molloy forcibly expresses it, 'to rot in her neglected brine.' Such desertion might involve a long delay of the vessel while the master is seeking another crew, an abandonment of the voyage, and in some cases the safety of the ship itself. Hence, the laws of nearly all maritime nations have made provision for securing the personal attendance of the crew on board, and for their criminal punishment for desertion or absence without leave during the life of the shipping articles."

37. "Sailor Boarding-House Outrages," *Morning Oregonian*, November 26, 1874.

38. Ibid.

39. "One Ship All Right: Takes Away the Same Crew She Brought to Port," *Morning Oregonian*, September 20, 1900.

40. Jewell, *Among Our Sailors*.

41. "Beneath the City, a Treasure Trove of Junk, Commerce," *Sunday Oregonian*, January 30, 1972; and Janet Goetz, "History Project Records Portland Recollections," *Sunday Oregonian*, December 21, 1975.

42. Robert Olmos, "Abandoned, Ghostly Chinese Gaming Den Found by Portland Demolition Workers," *Oregonian*, March 25, 1963.

43. "A Little Molehill," *Daily Morning Astorian*, January 28, 1890.

44. "Discrimination Is Charge: Chinese Would Restrain Enforcement of Secret Passage Ordinance," *Morning Oregonian*, March 1, 1914.

45. "John Chinaman's Jack-in-the-Box," *Sunday Oregonian*, November 17, 1935.

46. "May Advance Rates: Rumor That Sailor Boarding-House Opposition Is to Be Absorbed," April 2, 1902.

47. "Ship Libeled," *Morning Oregonian*, March 22, 1890.

48. "A Complaint by Shipmasters," *Morning Oregonian*, November 5, 1881.

49. "'Bunco' Kelly's Return," *Morning Oregonian*, July 22, 1907.

50. For information on this act, and a subsequent act of the Oregon legislature in 1903, see "City Council Proceedings," *Daily Morning Astorian*, November 27, 1889; and "Holds Law Valid," *Morning Oregonian*, January 12, 1904.

51. "Captains in It," *Morning Oregonian*, September 19, 1900.

Chapter 4

52. California State Tax Collections, Ledger, Div. 4, San Francisco, 1866.

53. The Turks had two sons: Frank and Charles. The 1880 census showed the Turks as a family of three, with little Frank listed as being "at school." His brother was most likely much older and may have been from a previous relationship of James Turk's. Charles was arrested in 1887 for attempting to murder Catherine Turk. Frank would have been fourteen at the time. Charles was equally as violent as his father.

54. From the booklet *Oregon: Facts Regarding Its Climate, Soil, Mineral and Agricultural Resources, Means Of Communication, Commerce and Industry, Laws, Etc.* (Boston: Oregon State Board of Immigration, 1877).

55. Throughout his autobiography, Joseph Kelley signed his name "Kelley," with an "e." No one else ever did, it seems. He spelled his other moniker "Bunco," whereas the papers spelled it either Bunco or Bunko. It is important to note that the word "bunco" was in constant use in the late eighteenth century. It could mean a swindle or a swindler, and nearly every newspaper was filled with stories of "bunco men" or a "bunco" that had been pulled on some poor soul. There was a "Bunco Jim," a "Bunco Bill" and many other people wearing the same title as Portland's own Bunco Kelley. The word "bunco" was also used interchangeably with the other spelling, "bunko."

56. *Morning Oregonian*, May 27, 1887.

57. The various tellers of this tale give it an exact location to amplify the authenticity of the tale, but they never manage to place the cigar store at its correct location. Wildman's Cigars was established at 15 First North, by B Street in 1885, until it moved to 222 Burnside around 1900.

58. Thirty-nine is the ridiculous number cited by Spider Johnson in the *Oregonian* interview of 1933. See Stewart H. Holbrook, "Shanghai Days in the City of Roses," *Sunday Oregonian*, October 8, 1933.

59. "X.N. Steeves in Jail: The Lawyer Arrested for Complicity in Sayres Murder," *Morning Oregonian*, October 9, 1984.

60. A slungshot is a maritime tool consisting of a weight, or "shot," affixed to the end of a long cord often by being wound into the center of a knot called a "Monkey's fist."

61. *Capital Journal* (Salem, OR), February, 13, 1895.

62. Ibid., November, 7, 1909.

63. I had a friend who attended the University of York in the mid-1960s. He had an elderly professor who, whenever confronted with something he saw as pretentious, used the odd expression "pillars of society in Portland, Oregon." Perhaps his grandmother had sipped tea with Mrs. L.M. Sullivan at her house at Eighteenth and Irving.

64. "City News in Brief," *Morning Oregonian*, May 27, 1895.

65. *Dalles Chronicle*, April 3, 1896.

66. The *Oregonian* reported his company as being the "L.M. Sullivan Investment Co," but his fellow Nevadan, investor and failed millionaire George Graham Rice, wrote much about Sullivan in his memoir *My Adventures With Your Money*, in which he recalls it as the "Sullivan Trust Company."

67. "May Advance Rates: Rumor That Sailor Boarding-House Opposition Is to Be Absorbed," April 2, 1902.

68. "Guns in the Air," *Morning Oregonian*, August 26, 1903.

69. "Ready to Kill," *Morning Oregonian*, August 27, 1903.

70. Ibid.

71. *Reports of Cases Decided in the Supreme Court of the State of Oregon*, Volume 44, Salem, OR: Supreme Court, 1904. It is interesting that the court documents refer to the plaintiff as "Mysterious" Billy Smith.

72. "Shorn of Power," *Morning Oregonian*, January 14, 1904.

73. Mr. Turk advertised it in the *Oregonian* at that time under the name "Portland House," although several other names were common, including the "Sailor's Home."

74. *The Sailor's Magazine and Seamen's Friend*, August 1882.

75. Reprinted in the *Annual Report to the Commission on Navigation* (Washington: Government Printing Office, 1899).

76. *The Sailor's Magazine and Seamen's Friend*, December 1888.

Chapter 5

77. Portland, East Portland and Albina became one city on July 6, 1891.
78. The poem appears in Joseph Gaston, *Portland, Oregon, Its History and Builders in Connection with the Antecedent Explorations, Discoveries and Movements of the Pioneers That Selected the Site for the Great City of the Pacific*, Vol. I (Chicago: The S.J. Clarke Publishing Company, 1911), 344.
79. The original Willamette River Bridge lasted until 1989, when locomotive engineers failed to notice that the span was in the open position and proceeded to put several locomotives along with the first in a line of railcars into the Willamette river. The bridge was rebuilt with a vertical lift replacing the draw span. Rail passengers going north are treated to a ride across this span and on into the Saint Johns railroad "cut" leading to the railroad bridge that crosses the Columbia River.

Chapter 6

80. *The Sailor's Magazine and Seamen's Friend*, December 16, 1874.
81. "Portland's Grain-Carrying Fleet," *Sunday Oregonian*, November 4, 1900.
82. To put this in perspective, compared to the 3,000 tons loaded by the bark *Europe*, the grain barges seen on the Columbia River carry 4,000 tons of grain; the ships that load in Portland often load 65,000 tons or more.
83. "Portland's Grain-Carrying Fleet," *Sunday Oregonian*, November 4, 1900.
84. John Ruskin (1819–1900), English philosopher and art critic.
85. Ibid.
86. "Big Elevator Completed: Everything Finished and Yesterday Operations Were Commenced," *Morning Oregonian*, October 4, 1889.

Chapter 7

87. "Harbor Bulkhead," *Oregonian*, January 18, 1900.
88. The French word *macquereaux,* meaning pimp or procurer, was often used in news reports of the day.

89. *Blagen v. Smith*, 34 Or. 394, 56 P. 292 (Or. 1899).
90. "New Dawn for Portland's Bad Land," *Sunday Oregonian*, December 26, 1915.
91. "Fat Billets," *Daily Morning Astorian*, January 23, 1884 (quoting the *Sunday Welcome*).

CHAPTER 8

92. Scott, *History of Portland, Oregon*.

CHAPTER 9

93. *Oregon Free Press*, August 12, 1848.
94. Sometimes referred to as the "White Squadron."

CHAPTER 10

95. "After Democratic Scalp," *Evening Capital Journal*, March 11, 1889.

CHAPTER 11

96. Sydney B. Vincent, "Portland the King of the Shipbuilding Industry," *National Service Magazine* (February–March 1918).

CHAPTER 12

97. "Torchlight Procession," *Morning Oregonian*, May 29, 1868.

98. "Strike Among the Longshoremen," *Morning Oregonian*, November 11, 1877.
99. "To the Merchants and Longshoremen of Portland, Or," *Morning Oregonian*, September 6, 1878.
100. *Report of the Industrial Commission on Transportation, Including Review of Evidence, Topical Digest of Evidence and Testimony so far as Taken, May 1, 1900,* Volume IV of the Commission's Reports (Washington: Government Printing Office, 1900), 689.
101. "Strike Not a Success," *Morning Oregonian*, August 1, 1900.

BIBLIOGRAPHY

Alborn, Denise M. "Crimping and Shanghaiing on the Columbia River." *Oregon Historical Quarterly* 93, no. 3 (Fall 1992).

Aldwell, Thomas T. *Conquering the Last Frontier.* Seattle: Artcraft Engraving and Electrotype Company, 1950.

Booth, Brian, ed. *Wildmen, Wobblies & Whistle Punks: Stewart Holbrook's Lowbrow Northwest.* Corvallis: Oregon State University Press, 1992.

Bowles, Samuel. *Across the Continent: A Summer's Journey to the Rocky Mountains, the Mormons, and the Pacific States.* New York: Hurd and Houghten, 1865.

Charter and General Ordinances in Force March 1, 1884: Laws of Paid Fire Department and Table of City Grades of the City of Portland. Portland, OR: R.H. Schwab & Bro., 1884.

Clark, Malcolm, Jr. *Pharisee among Philistines: The Diary of Judge Matthew P. Deady, 1871–1892.* Portland, OR: Oregon Historical Society, 1975.

Delgado, James P. *The Beaver.* Victoria, BC: Horsdal and Schubart, 1993.

Dillon, Richard H. *Shanghaiing Days.* New York: Coward-McCann, 1961.

Evans, Elwood. *History of the Pacific Northwest.* Portland, OR: North Pacific History Company, 1889.

Gibbs, James A. *Pacific Graveyard: A Narrative of Shipwrecks Where the Columbia River Meets the Pacific Ocean.* Portland, OR: Binfords and Mort, 1950.

Holbrook, Stewart. *The Columbia.* New York: Holt, Rinehart and Winston, 1956.

Jewell, J. Grey, MD. *Among Our Sailors.* New York: Harper Brothers, 1874.

Johansen, Dorothy O., and Charles M. Gates. *Empire of the Columbia: A History of the Pacific Northwest.* New York: Harper and Row, 1957.

Kelley, Joseph (Bunko). *Thirteen Years in the Oregon Penitentiary.* Portland, OR: Self-published, 1908.

Kirtley, Karen, ed. *Eminent Astorians: From John Jacob Astor to the Salmon Kings.* Salem, OR: East Oregonian Publishing Company, 2010.

Leigh, Dorothy. *World at Our Doorstep, Book I: Seaport on the Willamette.* Portland, OR: Binfords and Mort, 1953.

MacColl, E. Kimbark. *Merchants, Money and Power: The Portland Establishment 1843–1913.* Portland: Georgian Press, 1988.

Mills, Randall V. *Stern-Wheelers Up Columbia.* Lincoln: University of Nebraska Press, 1947.

Nelson, Bruce. *Workers on the Waterfront: Seamen, Longshoremen, and Unionism in the 1930s.* Urbana: University of Illinois Press, 1988.

Oregon: Facts Regarding Its Climate, Soil, Mineral and Agricultural Resources, Means Of Communication, Commerce and Industry, Laws, Etc. Boston: Oregon State Board of Immigration, 1877.

Report of the Secretary of War to the Second Session of the Forty-Second Congress, Vol. II. Washington: Government Printing Office, 1871, 1899.

Richardson, Albert Deane. *Beyond the Mississippi.* Hartford, CT: American Publishing Company, 1869.

The Sailor's Magazine and Seamen's Friend. American Seamen's Friend Society.

Scott, H.W. *History of Portland, Oregon, with Illustrations and Biographical Sketches of Prominent Citizens and Pioneers.* Syracuse, NY: D. Mason and Co., 1890.

Snyder, Eugene E. *Early Portland: Stump-Town Triumphant.* Portland, OR: Binford and Mort, 1970.

Tetlow, Roger T. *The Astorian: The Personal History of D.C. Ireland.* Portland, OR: Binford and Mort, 1925.

Wilkes, Charles. *Narrative of the United States Exploring Expedition During the Years 1838, 1839, 1840, 1841, 1842 (in five volumes and an atlas).* Vol. IV. London: Wiley and Putnam, 1845.

Wright, E.W., ed. *Lewis & Dryden's Marine History of the Pacific Northwest.* Portland, OR: Lewis and Dryden Printing Company, 1895.

INDEX

ABOUT THE AUTHOR

Barney Blalock is the great grandson of Oregon pioneer settlers to Tillamook County. He was born in central Oregon, raised in Yokohama, Japan, and finally came to settle in Portland. He worked on the Portland waterfront for thirty-three years inspecting export grain for the U.S. Department of Agriculture. Curiosity about his surroundings and the people he worked with eventually gave rise

Photo by John Blalock.

to a website about the history of the Portland waterfront and to writing this book. Barney is a member of the Oregon Historical Society and the Oregon Maritime Museum. He is now semi-retired and works as a writer and web manager. Father of three wonderful children and grandfather of two, Barney and his wife, Nektaria, live in Southeast Portland with their beloved cat Ralph.

Visit us at
www.historypress.net